NOTE ABOUT THIS SERIES

TO GET HOLD OF THE INVISIBLE, ONE MUST PENETRATE AS DEEPLY AS POSSIBLE INTO THE VISIBLE. THIS IS THE ESSENCE OF PAINTING. § THE ARTIST MUST FIND SOMETHING TO PAINT. PAVEL TCHELITCHEW SAID, "PROBLEMS OF SUBJECT-MATTER HAVE BEEN LIKE OBSESSIONS — IMAGES HAVE HAUNTED ME SOMETIMES FOR YEARS BEFORE I WAS AT LAST ABLE TO UNDERSTAND WHAT THEY REALLY MEANT TO ME OR COULD BE MADE TO MEAN TO OTHERS." THESE ESSENTIAL IMAGES AND THEMES IN A BODY OF WORK — PEOPLE, PLACES, THINGS — ARE EQUIVALENTS OF THE ARTIST'S INNER, INVISIBLE REALITY. § THE ARTBOOKS IN THIS SERIES EXPLORE SPECIFIC SUBJECTS THAT HAVE MOVED CERTAIN ARTISTS AND STIRRED OUR DEEPEST RESPONSES.

Joseph Stella, New York City, 1943, Photograph © Arnold Newman

A CHAMELEON BOOK

JOSEPH STELLA'S SYMBOLISM

Irma B. Jaffe

POMEGRANATE ARTBOOKS, SAN FRANCISCO, CALIFORNIA

A CHAMELEON BOOK

Complete © 1994 Chameleon Books, Inc.
Text © 1994 Irma B. Jaffe

Published by Pomegranate Artbooks
Box 6099, Rohnert Park, California 94927

Produced by Chameleon Books, Inc.
211 West 20th Street, New York, New York 10011

Creative director: Arnold Skolnick
Designer: Arnold Skolnick
Editorial assistant: Lynn Schumann
Managing editor: Carl Sesar
Composition: Larry Lorber, Ultracomp
Printer: Oceanic Graphic Printing, Hong Kong

Library of Congress Cataloging-in-Publication Data

Jaffe, Irma B.
 Joseph Stella's symbolism / by Irma B. Jaffe.
 p. cm. — (Essential paintings series)
 Includes bibliographical references.
 ISBN 1-56640-980-2
 1. Stella, Joseph, 1877-1946 — Criticism and
interpretation. 2. Symbolism in art — United States.
I. Stella, Joseph, 1877-1946. II. Title. III. Series.
ND237.5.S74J34 1994
759.13 — dc20 93-46655
 CIP

Acknowledgments

This book could not have been possible without the dedication and scholarship of the author, Irma B. Jaffe, who also translated Joseph Stella's notes about his paintings especially for this publication.

I thank all the museums who supplied the wonderful images. Special thanks to Margaret Di Salvi of The Newark Museum; Anita Duquette of the Whitney Museum of American Art; The Hirshhorn Museum; and the Iowa State Education Association.

I am especially grateful to Richard York from the Richard York Gallery; Gary Snyder from Snyder Fine Art and Betty Krulik from the Spanierman Gallery.

Many thanks also to all the private collectors, with special thanks to Mr. and Mrs. Barney A. Ebsworth; Philip J. and Suzanne Schiller; Joseph P. and Mrs. Carroll; and Harvey and Francoise Rambach.

Special thanks also to Toby Old and Clive Russ, who traveled far to capture some of the images on film.

I want to thank my colleagues at Chameleon who helped make this book possible: Carl Sesar, who did the editing; Jamie Thaman, who read the proofs; Larry Lorber, who set the type; Nancy Crompton, who did the paste-up; and Lynn Schumann, my assistant, who coordinated all aspects of production. Thanks also to Joanne Gillett and Halina Rothstein for their continued support.

Finally, I thank my wife, Cynthia Meyer, whose creative presence is felt in my work.

Arnold Skolnick

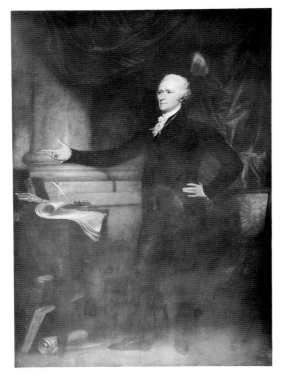

John Trumbull, ALEXANDER HAMILTON, New York City Hall
The column and drapery are standard symbols of social importance.

Cesare Ripa, Temperance

Piero della Francesca,
TRIUMPHAL PROCESSION OF FEDERIGO DA MONTEFELTRO
Uffizi Gallery, Florence, Italy
Photograph courtesy of Scala/Art Resource, NY

Federigo is escorted by the four Cardinal Virtues: Justice, Prudence, Fortitude, and Temperance. Justice holds a sword in her right hand, scales in her left, in accordance with traditional iconography.

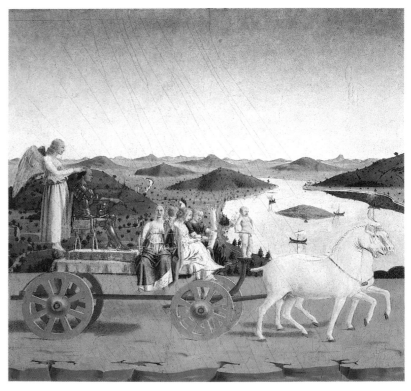

THE EXTRAORDINARY range of both subject and style in Joseph Stella's art over the decades of his career—c. 1905 to c. 1940—comes into integrated focus through the lens of his symbolism.[1] Stella's stylistic freedom, from precise representation to abstraction; his choice of subjects, from nature to technology; the various objects that constitute his visual vocabulary, from birds to bridges; and his compositional characteristics must all be given close attention in order to understand the personal mythology of this Italian-American artist. Like a bridge spanning opposite sides of a great divide, half-European, half-American, Stella swung aesthetically and culturally from one side to the other, not always aware himself of how his images symbolized his life experience.

Until the modern age, symbols used in the visual arts were of a public nature. Virtues and vices, the various arts, and the seasons were embodied in a set of established and widely recognized allegorical figures arranged in standard reference works used by artists.[2] So also with personal attributes, which were identified by conventional signs that stood for qualities such as beauty or strength, or biographical signs for rank, lineage, or occupation that identified a real or mythological figure's social role. But with the development of individualism, a hallmark of the modern age in Western culture, these allegories and attributes in the visual arts gave way to personal, often private symbols of the artist. Indeed, self-reference began to appear in painting and sculpture as a self-consciously *modern* feature around the middle of the nineteenth century in images of contemporary life as the artist experienced it. Examples are Courbet's *Burial at Ornans*, representing the funeral of the artist's grandfather, and *The Studio: A Real Allegory of Seven Years of My Artistic Life*. Objects and places also came to serve as metaphors for an artist's emotional or psychological states. One may say that Stella joined the ranks of Modernism when he moved from the represen-

tational imagery of his early years, as in *Painter's Row: Workers' Houses* (1908), to the self-expression of *Battle of Lights, Coney Island, Mardi Gras* (1913). His conversion was accomplished almost in one great leap from the past to the present.

3

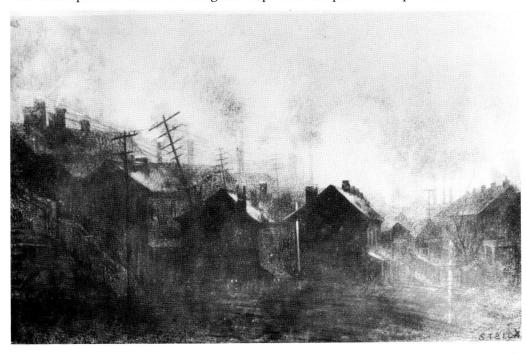

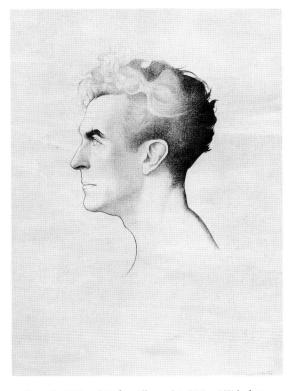

Portrait of Edgard Varèse, Silverpoint, 20¼ x 14⅝ inches
Collection unknown.

To interpret works in the modern field thus requires knowledge of the artist's life in all of its cultural aspects, both general and personal. Fortunately for historians and critics interested in Stella, his need for self-expression was almost as verbal as it was visual. He was constantly making notes about where he was, what he was doing, what he was feeling—notes written on the backs of envelopes, restaurant menus, or other equally ephemeral scraps of paper. Thrown into a large carton, these hundreds of "scritti," "ricordi," or "pensieri," as the artist labeled them, were saved by his nephew, Sergio Stella, who gave them into the temporary custody of the present writer.[3] In these self-revealing, scribbled, blotted, and all but illegible notes, written in Italian, we will look for clues to explain the strangely ambiguous and ambivalent nature of Stella's pictorial symbols.

By all accounts Joseph Stella's was a complex and contradictory personality. Edgard Varèse, the modernist composer, remembered that Stella's mood was sometimes friendly, and other times inexplicably hostile. Stephan Bourgeois, one of the first art dealers to sponsor modernist art in the United States, described convivial gatherings of artists at which Stella was often called upon to recite something. If he was in a good mood, he would respond to such requests. On one occasion, Stella, a heavy set, bulky man, transformed himself before everyone's eyes into a delicate, fragile Desdemona and spoke her lines from *Othello*. August Mosca, an artist friend and disciple of Stella's, recalls how changeable he was: "You never knew what to expect when you went to meet Stella." In an article about Stella in *The Arts*, the editor and publisher Hamilton Easter Field saw both the artist and the man as someone "delicate, full, rich, opulent…like a beneficent power of nature…like a strong southern wind."[4]

Manuscript page of Stella's notes for his autobiography

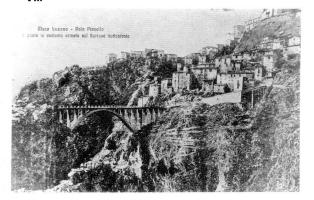

Photograph of Muro Lucano

Stella *was* a southerner, born in 1877 in Muro Lucano, a village perched high in the hills east of Naples, where, in his nostalgic imagination years later, every day was sunny and warm. We can imagine him as he arrived in New York on the *Kaiser Wilhelm* in 1896 at the age of eighteen looking like the young southern Italian described in "I Giocatoli Rotti (The Broken Toys)," a short story by Corrado Alvaro, Stella's contemporary.

> ...a young man, a student by appearance, of that intense darkness of certain South Italians on whose faces the clearly outlined and thick eyebrows open out like two feathers.... He moved, half embarrassed and half distinguished, with an acquired distinction and a natural embarrassment; his head full of...cavils which give South Italians an expression of avidity, a flash of pride in their eyes, as if they were sharers of the secrets of the past. South Italians feel the past strongly; they stand in it as in the shadow of a mother.

Such was Joseph Stella, whose *paese,* his native region, was so much more than just the place where he was born. It was where the people looked like the living rock and fieldstone of the hillside that provided the material for their sturdy houses—houses

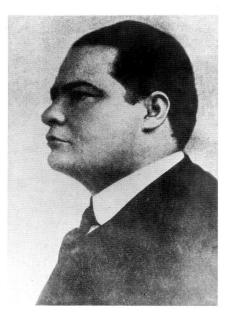

Photograph of Stella as a young man

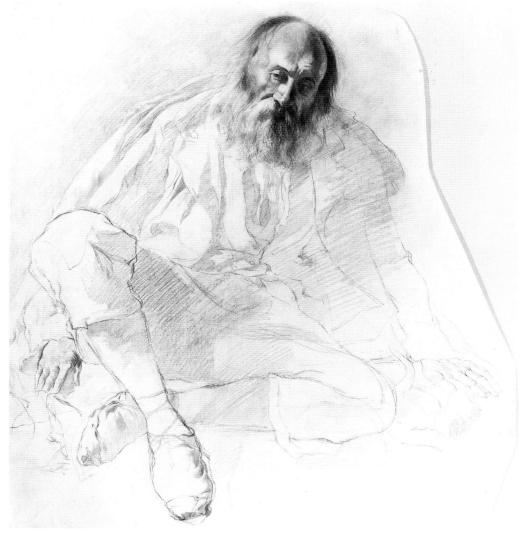

SEATED OLD MAN, c. 1900
Pencil, 20½ x 19⅛ inches
Courtesy of Richard York Gallery, New York City

that leaned against each other back to back, standing in the protective shadow of the church whose tolling bells filled the air and counted the rosary of hours for the villagers. Shepherds, dressed in their traditional short trousers, jackets, tassled caps and peasant shoes, still paraded into the village at Christmastime, as they had for centuries, playing their bagpipes and singing solemn hymns and prayers, and every mother with her baby was a Madonna. An immense valley spread itself against the rise of the cliffs where he first knew aesthetic joy and sexual passion, and where the golden light of the sun "opened the sky" each morning, and descended, "amber and honey-colored," in the evening. A close friend of Stella's, the sculptress Clara Fasano, recalled traveling with Stella on a train from Paris to Italy when

> a fellow passenger started to pull down a window shade against the sun that was streaming into the car. Stella shouted at the man, "You don't know how fortunate you are to live in this beautiful, sunny Italy! I come from gray, foggy countries, and now I am blessed with the beautiful sun you want to deprive me of by pulling down the shade!" Stella went to the window, raised the shade, and left the young man standing speechless at the sudden attack.[5]

Living in New York where winters are cold, Stella yearned for the south; living in the modern city, he yearned for nature; living in a materialist culture, he yearned for spiritual nourishment. Never known, as an adult, to go to church, he was deeply religious. Underlying all his yearning was a powerful emotion stirred in him by the intertwined passions of sex and art, passions masked in bridges and factories, in birds and flowers, in pagan goddesses and Madonnas.

Were these dualities resolved in the act of expressing them in painting? It does not seem so. The lifelong contradictions in his personal behavior and his insistent return, in his art, to the same compositional device—symmetrical balance on each side of a central axis—suggest unrelieved tensions in Stella. Even in his early drawings, one may find clues to them. Consider, for example, *Pittsburgh II: Italian Leader* (1908), a masterpiece among Stella's works on paper in which the contrast of light and dark that divides the left and right sides of the subject's face confounds the character of the labor leader and leaves the viewer wondering what to believe about him—a man to be wary of, or trusted? In this work we see also the irregular pointed edges of the silhouette that would remain characteristic of Stella's style.

How does an artist find his subjects? Before the modern age this question could not be asked, since art was ordered by patrons who knew what they wanted: altarpieces to donate to the church, religious and decorative compositions for their palaces, and portraits of themselves and family members properly identified with status symbols referring to their wealth, power, and achievements. Now, problematically liberated from service to nobility and clergy, and competing among themselves in the new capitalist marketplace, artists began to seek new subjects, and gradually persuaded potential "patrons," now customers, that any and all objects and places were appropriate as subjects; the line from Manet's paintings of everyday bourgeois life such as *La Musique aux Tuileries* (1862) to Stella's abstract *Battle of Lights, Coney Island, Mardi Gras* (1913) is a straight one.

But Stella's Coney Island is neither as genteel as the Tuileries Garden in those days nor as ordinary as the teeming Lower East Side of New York, where in the first decade of our century the Ashcan painters found inspiration in the everyday life of working-

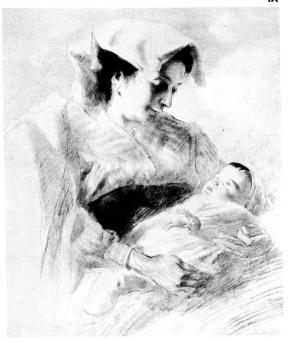

MOTHER AND CHILD, c. 1922
Crayon and chalk, 24 x 20 inches
Collection unknown

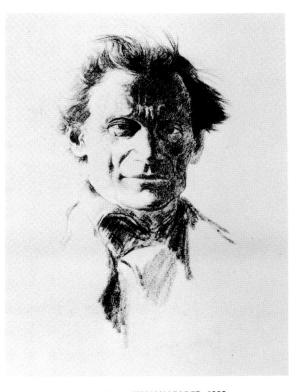

PITTSBURGH II: ITALIAN LEADER, 1908
Conte crayon, 3½ x 19 inches
Collection unknown

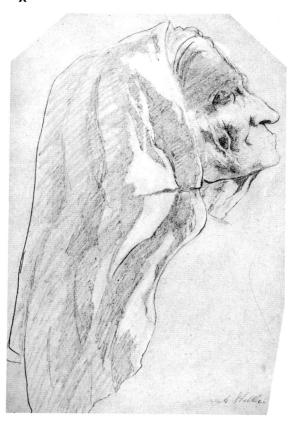

PROFILE HEAD OF AN OLD WOMAN, c. 1922
Pencil and chalk, 15⅜ x 9 inches
Collection unknown

class people. The atmosphere of the urban amusement park filled with crowds of city dwellers was boisterous and frenzied, a place of contradictory feelings, of "dangerous pleasures." Or so it seemed to Stella as he responded to Coney Island's appeal in language as erotically suggestive as it is aesthetic.

> Making an appeal to my most ambitious aims—the artist in order to obtain his best results has to exasperate and push to the utmost his faculties—I built the most intense arabesque that I could imagine in order to convey in an [sic] hectic mood the surging crowd and the revolving machines generating...not anguish and pain but violent, dangerous pleasures. I used the intact purity of the vermilion to accentuate the carnal frenzy of the new bacchanal and all the acidity of the lemon yellow for the dazzling lights storming all around.[6]

Battle of Lights is Stella's most important Futurist-related work. The influence of Italian Futurism on Stella is, however, problematic, just as is the general question of mutual influences between French and Italian avant-garde painting in 1912. Stella had spent a little over a year in Italy from late 1909 to early 1911, but he had had no contact there with the newly formed, exuberant Futurist movement. In February 1912, however, he was in Paris at the same time the Futurists were having their important exhibition there. It was then that Stella first saw their work. *Battle of Lights* bears some resemblance to the Futurist painting at the exhibition, particularly its expression of physical and psychological sensations created by its dense composition and dynamic line. It is useful to remember, however, that an Expressionistic current had emerged in western European painting, partly, perhaps, in reaction to the formal, stable quality of Cubism as practiced by Picasso and Braque. Painters such as Jacques Villon, Francis Picabia, and Robert Delaunay, all working in Paris at that time, had created imagery that suggested dynamic movement. Stella had seen the explosive *Nude Descending a Staircase* by Marcel Duchamp at the landmark Armory Show in New York in 1913 and may even have seen it earlier when it was shown twice in Paris in 1912.

Battle of Lights synthesizes Stella's responses to all of the works he had seen, and as revealed in the passage quoted above, is charged with a *personal* content. Loving the great crowds and yet fearful of them, Stella the artist seems to have projected himself into the spectacle of Coney Island as a participant. At the lower right edge of the painting, next to the black elephant, one can discern a profile head masked in a crazy quilt of colors. The general shape of the profile, planted almost neckless onto bulky shoulders, strongly suggests Stella himself.

The most ambitious of all of Stella's works is the five-part painting known as *New York Interpreted,* but also called by Stella *Voice of the City* (1920–1922). [The Newark Museum titles this work *The Voice of the City of New York Interpreted.*] Its monumental size, along with its accomplished visualization of Stella's innovative concept, complex iconography, and magisterial execution, make it one of the masterpieces of American art. Never in American art have art, sex, religion, and self-reference been more successfully bonded.

The sources of such a painting are many and varied. First, it is useful to consider that historically "the city" as a pictorial motif had been treated somewhat abstractly as a symbol of divine power, and representationally both as a view and as an environment for human activities. Among Stella's papers we find clippings of magazine illustrations of the fifth-century apse mosaic in the Church of Santa Pudenziana in Rome (with its semi-abstract depiction of Jerusalem) and of Ambrogio Lorenzetti's

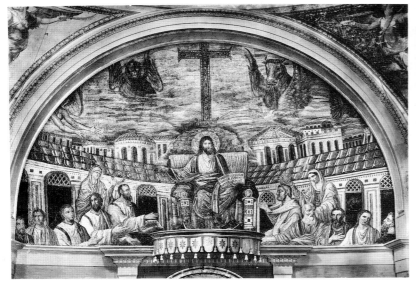

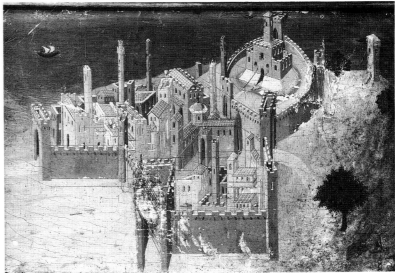

fourteenth-century painting *Veduta di Città*, both of which probably provided ideas for *New York Interpreted*.

The polyptych form of this work is an extraordinary example in modern art of the bonding of structure and iconography. Altarpieces were often composed of multiple panels, with small panels, called predelle, at their base, and with the center section taller than the others. By alluding to such altarpieces, the structure of *New York Interpreted* makes a symbolic statement and leads the viewer to see that the artist intended to evoke spiritual feelings about the city.

Probably the first artist to express, rather than describe, the character of a particular city was Robert Delaunay. In his *La Ville de Paris* (1910–1912), he combines motifs from the bridges over the Seine, the Eiffel Tower, and semi-abstract renderings of The Three Graces to symbolize the dynamic creativity of the city presided over by Joy, Harmony, and Brilliance. Stella must have seen this huge painting at the Salon des Indépendants exhibition in 1912, and had surely read the suggestive, vivid evocation of the modern city in Filipo Marinetti's "Initial Manifesto of Futurism" (1909), which clearly seems to have contributed to the stream of ideas that Stella eventually gave form to in his *New York Interpreted*.

> We shall sing of the great crowds in the excitement of labour, pleasure and rebellion; of the multi-coloured and polyphonic surf of revolutions in modern capital cities; of the nocturnal vibrations of arsenals and workshops beneath their electric moon...of factories suspended from the clouds...of bridges leaping like gymnasts over the diabolical cutlery of sunbathed rivers.[7]

A further source for the development of Stella's ideas for a great portrait of New York, and possibly for his original title, *Voice of the City*, might very well have been a book by Frederick C. Howe, Commissioner of Immigration at the Port of New York, since Stella illustrated an article by Howe in 1916. In this book, *A Modern City and Its Problems,* Howe quoted from *Emancipation of the Medieval Town*: "Splendid monuments arose...and churches lifted toward heaven their domes, campaniles and spires....The town bell was the public *voice of the city* [emphasis added] as the church was the voice of the soul."[8] Stella's great achievement was in orchestrating these widely variant influences into a single powerful composition.

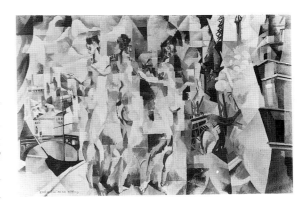

At the center of *New York Interpreted* is "The Skyscrapers." The composition, **11** dominated by a dark tonality, is symmetrical along the left and right sides of a strong central axis that is propelled upward as if by some powerful force. Radiating like a halo from its spire are seven rays of light, so that the tall buildings seem to be uplifted, like an apotheosis, on wings of light, reminding one of religious paintings in which the heavenly world is represented as cloud-borne above the earth. The number seven has several mystical associations, including the seven doves that symbolize the seven gifts of the Holy Spirit. This winged image is also seen in art as an attribute of Peace. Indeed, as one may expect from an Italian artist brought up "in the shadow of the church" and also deeply familiar with religious Italian art, "The Skyscrapers" resonates with Christian symbolism.

Flanking "The Skyscrapers" and contrasting with it in color and mood are the two panels called "White Way," referring to Broadway, New York's theatrical district. Painted in bright colors and crammed with motifs and lettering, the panels suggest something of the frenetic atmosphere created by the glaring, blinking, colored lights on theatre marquees.

At the far left is "The Port," seemingly asymmetrical until one notices that there **9** is indeed a central axis topped by a bright beacon set in "deep blue-green that dominates the sky and water," Stella wrote, revealing the beacon's symbolic content "like a triumphant song of a new religion."[9]

The best known of the sections of *New York Interpreted* is "The Bridge" at the **13** extreme right. Its gothic towers make it immediately recognizable as the Brooklyn Bridge, the architectural and engineering masterpiece of John and Washington Augustus Roebling, father and son. Stella had already portrayed the Brooklyn Bridge in a major work of 1918 – 1919. It is not too much to say that both bridge paintings are self-portraits: their autobiographical content is made explicit in Stella's autobiographical notes and in his essay "Brooklyn Bridge, A Page of My Life" (suggestively **8** echoing Courbet's title for his studio painting), in which he described the powerful feelings the bridge stirred in him. He recalls how, in his intense effort to express his response to the bridge, he experienced "days of anxiety, torture, and delight alike, trembling all over with emotion...."[10]

THE VOICE OF THE CITY OF NEW YORK INTERPRETED, 1920-22
Oil and tempera on canvas, 99¾ x 270 inches
Collection of The Newark Museum
Purchase 1937, Felix Fuld Bequest Fund

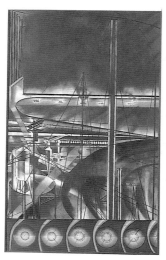
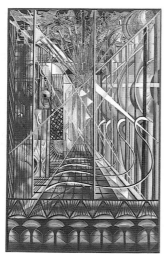
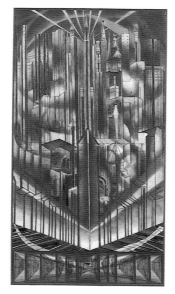
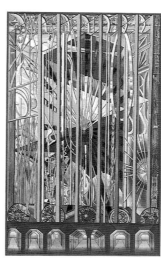
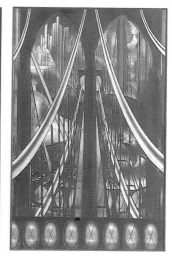

Like an actor who makes all the world a stage, Stella saw the bridge as a space on which to enact his emotions. It was an "Apparition...traced for the conjunction of Worlds...the cables, like divine messages from above." The bridge was "a shrine...the eloquent meeting point of all the forces arising in a superb assertion of powers, in Apotheosis." Standing on the bridge he felt "deeply moved, as if on the threshold of a new religion or in the presence of a new DIVINITY...."[11]

Of the five paintings that compose *New York Interpreted,* it was "The Bridge" with which Stella most closely identified. The painting is organized around a central axis suggestively shaped by the cables at the top. The phallic nature of the axis is evoked by the rounded shapes of the distant bridge. But the masculine expression merges with a feminine image as the inner cables shape the central form like a long dress and the great cables come forward like the welcoming arms of a great mother figure. "Alma Mater of the derelict of all the world," Stella addressed New York, "...your bridges hang like aerial highways through the chimeric fortunes of the future."[12] Self-reference underlies *New York Interpreted* overall. Stella sees the growth of New York as "parallel to the development of my own life." Revealingly, he writes of the city's "conquests" in his characteristic language of masculine domination, but refers to the city as feminine: "She is the center of the world."[13]

Symbols of power and the tone of celebration expressed in his writings about New York and in the visual imagery of *New York Interpreted* do not, however, convey the whole meaning of the work. These affirmations are offset by negative signs, most obviously by insistent, repeated verticals and, in the "White Way" sections, by crammed, suffocating spaces that suggest a prison. Stella writes of "the skyscrapers like bandages covering the sky, stifling our breath, life shabby and mean, provincial, sometimes shadowy and hostile like an immense prison." Hidden behind the thin wiry cables in the harp-like form framed in the arch on the right are tiny dots that form the word "PAID." Difficult to see, they are like the perforations on a canceled check, a reading that is confirmed by Stella's collage *Study for Skyscraper* (c. 1920), which includes a fragment of a canceled check on which the same letters, PAID, are easily read. This city of the Virgin, we come to understand, is also the city of Mammon: sublime and evil, exalting and demeaning, a prison-altar.

By 1923, when *New York Interpreted* was exhibited for the first time in the galleries of the Société Anonyme, Stella had established himself as one of the most significant artists painting in the United States. Henry McBride, one of America's leading art critics, began his review saying, "So far, more people have asked me what I thought of Joseph Stella's new work...than have inquired into any other event of the season." And yet, his work did not win unqualified approval. "I had set myself, upon seeing the pictures, the task of having a clear opinion of them," McBride went on,

> but without first-rate results; and it occurred to me that others had some uncertainties, too, and hence the questioning. There was no insinuation anywhere of opposition...but...no loud shout of joy reached the heavens when the pictures were shown. They were impressive, they were interesting, they were undoubtedly sincere, but...were they what we were all waiting for? Maybe they were. Perhaps we'll simply have to get used to them...there is an enormous amount of aspiration, an enormous amount of intellectual energy in them, and generalship in the execution—but also a lot that offends.[14]

Perhaps McBride was "offended" by what he called the "ferocious amount of

STUDY FOR SKYSCRAPER, c. 1920
Collage, collection unknown

parallelism" in the design, referring apparently to Stella's repeated vertical lines, his symbol of "whipped up, rising, climbing movement." One may agree that the repetitions do not work exactly as the artist intended, and even regret that the five individually powerful paintings are not perfectly unified. But despite flaws, *New York Interpreted* stands today as a unique effort to express the overwhelming grandeur and vulgarity, mystery and banality, that New Yorkers and visitors alike feel about this city. It succeeds as a masterpiece: it conveys the power and inspiration that are the real character of New York.

In the oeuvres of many artists, a specific period of time is marked by a particular style because either the subject matter or certain formal aesthetic problems may have interested them at the time. There are exceptions, of course—Picasso painted classicizing figures at the same time that he executed important works in the style of Synthetic Cubism (c. 1918–1922). It is interesting that in those years, Stella, too, worked in different styles, exemplified by the bridge and other industrial subjects on one hand, and the bucolic *Tree of My Life* (1919) on the other. **14**

At first glance, this light-colored, flower-and-bird-filled composition suggests a Garden of Eden. It seems to have been painted shortly after Stella finished *Brooklyn Bridge,* and was meant to convey the artist's jubilation at the restoration of peace after World War I and the promise of a new era just beginning. A second look quickly challenges the first impression as one notices the painting's peculiarities. The supposedly bucolic image is as crowded and frenzied as Stella's representation of bustling urban life in *Battle of Lights.*

Embedded in the tangle of branches and stems one finds blade-shaped leaves, claw-like clusters, spidery tendrils, daggerish petals, and saber-beaked birds that are undersized and out of scale next to the oversized blossoms and butterflies. To the right of the tree Stella has incorporated a few small remembered scenes of his birthplace, Muro Lucano—a pond on which a swan glides; above it, an arched bridge; and a group of peasants standing near the summit of the hill on which Muro Lucano is built. Dominating the center is the autobiographical tree that rises along the vertical axis (as in the New York paintings) to embrace, at the top, a circular form reminiscent of a monstrance. The tree's thick and deformed trunk, according to Stella, is a metaphor for "the first fierce struggles in the snare that Evil Spirits set on our path."[15]

Stella was not programmatically religious, but his writings and paintings reveal that his responses to the world were compellingly influenced by his upbringing in a Catholic culture.[16] In 1934 he exhibited a number of plainly religious subjects in Rome at *La Mostra Internazionale d'Arte Sacra,* including, among others, *The Crèche* **31** (1929–1933), *Virgin of the Rose and Lily* (c. 1926), and *Head of Christ* (c. 1933), all **16** painted between 1922 and 1933. In addition, there is a *Nativity* (1919–1920) probably **6** painted much earlier and a number of works that are religious in meaning but whose actual imagery is not specific, such as *A Child's Prayer* (c. 1919) and *La Fontaine* (n.d.). **7, 30** Still others carry religious meaning only for the artist: for example, Stella describes *Song of the Nightingale* (1918) as an aerial hymn that rises from the deep cradle of the **4** mountain, "a sacred reliquary of early dreams."[17]

The paramount religious image for Stella was the Madonna, who is the subject of five paintings. In one of them, *The Apotheosis of the Rose* (1926), she appears only **15** as the symbolic flower. Of the four figurative versions, the earliest is *The Virgin*, which **17** Stella painted in Naples in 1922. This and other paintings executed during his Italian

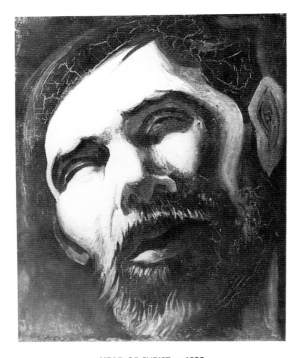

HEAD OF CHRIST, c. 1933
Oil on canvas, 9½ x 7½ inches
Private collection

sojourn at that time reveal that Stella was turning to the monumental Italian tradition rooted in Giotto and Piero della Francesca. One particularly sees the influence of Piero's geometrically conceived figures in *The Virgin*, the spherical head surrounded by an oval veil and supported by a cylindrical neck. Here Stella seems to have followed the allegorical tradition of the Virgin as the bride of the *Song of Songs*: "The flowers appear on the earth; the time of the singing of birds is come..." (1:12); "A garden enclosed is my sister...Thy plants are an orchard of pomegranates, with pleasant fruits..." (4:12 – 13).

18 In 1926 Stella was again in Naples, and once again took up the theme of the Madonna with two paintings. One, *Mater Dei* (c. 1926), represents her as a young Italian mother, a peasant it would appear from her large, capable hands; and the other, **19** *Purissima* (c. 1926), as a majestic queen, her purity symbolized by the dazzlingly white swans that guard and venerate her. Here, in addition to the influences noted above, Stella was probably responding to the statues in his village churches, which, with their "hieratic and archaic draperies falling in straight, narrow folds, awakened memories of Egypt and Greece."[18] He took up the Madonna theme for the last time with *Virgin of the Rose and Lily,* this time creating a nun-like figure whose head and neck are clearly based on the *Madonna* of 1922. In all of his Madonna paintings, the primary emphasis is on the Virgin's creative nature, symbolized by birds and flowers, which Stella identified with artistic creativity. In Assisi, he recalled, the places associated with saintly acts of St. Francis and St. Clara were marked with flowers kept always fresh, "just as, through the centuries, the lives of glorious artists appear [fresh], like miraculous flowers." One of those "miraculous flowers" was Giotto, he wrote, "a sacred name the sound of which penetrates our soul."[19]

In these works, as in *New York Interpreted*, one sees how skillfully Stella integrated a variety of contemporary aesthetic ideas—the decorative in Oriental art, the iconic in archaic, and the representational in southern Italian folk art. One particularly **32** interesting example of this synthesis can be seen in a later work, unfinished, *Still Life with Putto and Figurines* (c. 1943), one of several late paintings for which he used as models small carved figurines that he bought in Italy.

This painting was sold to its current collector under the title of *Toys*, bestowed upon it by its former owner. The objects do indeed look like toys, but reflecting on Stella's concerns as an artist makes one think twice about such a direct interpretation. Indeed, the putto's frontal position and pose do suggest a far more serious content—a representation of the Christ Child. Stella has arranged the "Child" so that its lower legs are hidden, inviting the impression that it is levitating. In the crook of his left arm, held open in a revelatory or protective, sheltering gesture, he holds a statuette, incompletely painted, that strongly resembles a Madonna in a blue mantle. The white blob in his right hand would most likely be a globe representing the world. Behind the "Child," on the right, a framed flower on a dark background calls to mind a stained-glass window, which is contrasted with a brightly colored floral pattern opposite; the pairing of light and dark suggests birth and death. The small figurines are under the protection of the Child, a theme underlined, perhaps, by what is probably meant to represent a piece of coral, traditionally used as a charm against the "evil eye."

Always a man of extremes, it is not surprising that when Stella painted his chaste Madonnas he also turned to mythological nudes. Different as these paintings are in style and subject, there is also a profound link between them. Draining the nudes of

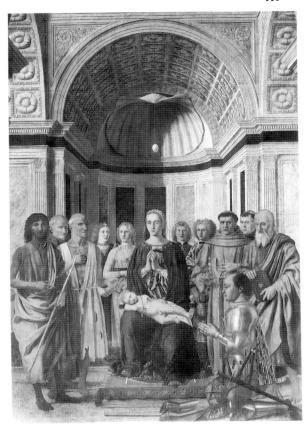

Piero della Francesca, MADONNA WITH THE CHILD, ANGELS, SAINTS AND FEDERIGO DA URBINO, late 15th century, Pinacoteca di Brera, Milan, Italy Photograph courtesy of Alinari/Art Resource, NY

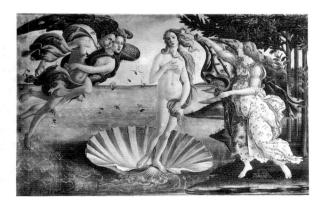

Cesare da Sesto, LEDA AND THE SWAN
(after Leonardo da Vinci), Galleria Borghese, Rome, Italy
Photograph courtesy of Alinari/Art Resource, NY

Sandro Botticelli, THE BIRTH OF VENUS
Uffizi Gallery, Florence, Italy
Photograph courtesy of Alinari/Art Resource, NY

Venus is identified by the pose of the female nude; she is wafted to
Cythera by the zephyrs, and welcomed by Flora, goddess of spring,
wearing a flowered dress and accompanied by the Three Graces:
Joy, Harmony, and Brilliance.

tactile appeal in favor of the sensuality of color, Stella seems to have intended to dematerialize them, so that they might, like the Madonnas, represent spiritual creativity, but transformed in the nudes from a religious content into one of art and sexual love; despite his intentions, the erotic element persists in informing the spiritual.

Stella's descriptions of *Leda and the Swan* (1922) and *The Birth of Venus* (1922) match the curiously combined chastity and eroticism of the images; his conflation of art, religion, and sex is equally manifest verbally and visually. In a prose poem about his *Leda* he writes that "the act of love...is sanctified...a kind of christening...the swan...flings itself upon Leda as if upon an altar."[20]

The phallic shape of the swan and its explicit position above the nude female body seem to make words unnecessary for understanding this work. Yet, there is more here than what is obvious. The myth tells of Zeus, ruler of Olympus, who, in the guise of a swan, made love to a mortal woman, Leda. She became the mother of Castor and Pollux, symbols of courage, and of Helen, symbol of beauty. How, one may ask, did Stella "read" this myth? What did this divine intercourse mean to the artist? Surely he found attributes that for an artist figured as primary values—aesthetic courage and beauty incarnate.

Stella was born an inheritor not only of the ancient classical tradition, but also, and equally compelling, of the southern Italian world deep-rooted in Christian imagery. Reading Stella's prose poem to Leda one finds references to purity, innocence, and divine radiance that have their source in Scripture. As his artistic perceptions developed, the religious vocabulary he learned in his youth was transformed into a richly resonating mytho-Christian aesthetic vocabulary. Thus, in *Leda*, while the composition is erotic, the nude figure of the classical maiden is curiously devoid of provocative sensuality as she reclines against an altar-like support, a passive, sacrificial offering. The gold coloring of her flesh, according to the poem, refers to the purity of gold, while the whiteness of the swan also symbolizes purity: the procreative act in the divine realm is spiritual rather than physical.

For Stella, making art was a divine act. A work of art was a physical thing of canvas and paint animated by its spiritual content. Leda and the swan are immersed in the color blue, symbolizing the celestial realm, and also water, the medium of baptism. Flowers, fish, and coral identify the tropical setting where, according to Stella, after each period spent in New York he felt his creative energies reawakened, his youthful passions restored. Deeply attached to his southern *paese*, Stella chose to ignore the fact that his most powerful work was inspired, and painted, in New York.

Writing of *The Birth of Venus* he tells of being shaken with joy as he suddenly saw in his imagination the painting he wanted to do. He was "thrilled by the act of possession...assaulted by a violent desire...."[21]

A critic writing in the *New Yorker* was puzzled by Stella's nudes. "If he insists on even his fish being things of beauty, why not his women? An interesting analytical study could be made of Stella and his interpretation of the female form," he observed, "...there is a spot of fear there that to us mars an otherwise perfect execution."[22] The critic's observation is enhanced when one realizes that Stella's *Leda* bears a physical resemblance to himself, although perhaps it is not surprising that Stella could project his own image in the form of a woman when one remembers the impression Stephan Bourgeois had of Stella transforming himself into a graceful, tender Desdemona.

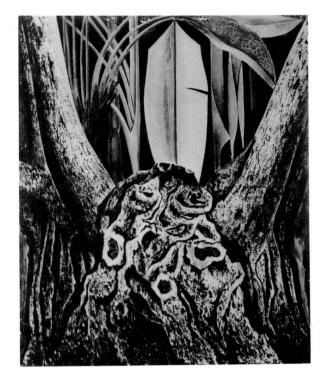

One of the most intriguing of Stella's paintings of the female figure is a late work, *Golden Fall* (1940). With her face turned away from the viewer, interest is focused on the woman's thick ropes of hair, which are like tropical tree roots, or the cables of Stella's *Brooklyn Bridge*. Like the bridge cables, the ropes of hair are realized through a system of light and shade that rounds them, and they open up away from the center to the margins of the picture plane. The pointed shape formed by the spreading apart of the hair penetrates the mass of hair with suggestive sensuality. The figure seems to be in flight, to judge by the pose. Knowing Stella's mind to be well furnished with ancient myths, and being aware of his way of fusing aesthetic and sexual imagery, it appears likely that this figure represents the nymph Daphne, fleeing from Apollo's lust and saved by her father, the river-god Peneus, who turned her into a tree right before Apollo's (and the viewer's) eyes.

The peculiar sense of animated life that Stella's works communicate is rooted in his perception that all of nature is a dictionary of symbols—trees become praying figures, and flowers, fruits, and vegetables become breasts and phalluses in his erotic imagination. In his memoir *Puerizia acerba di volutta* ("Budding Passion"), he writes,

> From the tree of my blossoming life, fragrant with flowers and melodious birds singing the psalm of spiritual joy, suddenly there arose without warning, sharp-pointed and thorny, the first fruits of sensuality—harsh, bitter, yet filled with wild and delicious perfume...
>
> Desire erupted imperiously, its demands sharper and more cutting with each day. It claimed the immediate satisfaction of its needs....In the sleepless night, like smoldering timber, like an eternal flame, I burned with the vision of virgin breasts, firm as a glistening crystal globe, pink, tempting....I sharpened the knife of my violent desire which cut and opened them like mysterious fruit, feeling in that moment a spasmodic voluptuousness of relief and liberation.[23]

Even the earth itself is a surrogate for the erotic artist. In a meditation, "Morning," he writes, "The earth, wrapped in its brown mantle embroidered with deep green, quivers in its first awakening like a voluptuous lover."[24]

As stated at the outset of this exposition of Stella's art, not only things depicted but also their arrangements—particularly Stella's insistent emphasis on a central vertical axis, regardless of subject—must be examined for symbolic meaning. Sometimes that centrality is not immediately apparent, as in *Neapolitan Song* (1929), with Vesuvius and its plume of smoke in the background. More characteristic is the dramatic *Full Moon, Barbados* (c. 1940), which perhaps more strongly than other works reveals Stella's love for the Old Masters of the Italian Renaissance. Their paintings, structured around a vertical axis at the center, were almost entirely religious in content, and make one wonder what impact the combination of centrality and religious content had on Joseph Stella. *Full Moon, Barbados* is dominated by the dark, thorny, sharp-pointed form at the center contrasted with the bright yellow, smoothly round, radiant moon—a moon, moreover, pierced by the thorns at its center. At the sides are two large birds, partly fanciful, and a small duck-like bird squats at the lower margin. For a viewer familiar with Renaissance painting, the composition is overlaid with countless memories of haloed Madonnas flanked by saints, and crucifixions: Christ with a crown of thorns and a golden halo, flanked by the two thieves, with Mary, John, and sometimes other saints disposed symmetrically at either side of the cross.[25]

Margin numbers: 33, 8, 22, 24, 25, 26, 27, 23, 29

STILL LIFE, c. 1939
Pastel on paper, 28¼ x 21⅝ inches
Hirshhorn Museum and Sculpture Garden, Smithsonian Institution
Gift of Joseph H. Hirshhorn, 1966
Photograph: Lee Stalsworth

This reading of centrality linked to Renaissance painting and religious content in Stella's compositions does not negate or preclude an additional determinative factor, based on the artist's writings.

> My dream, my longing as an artist is to put myself *at the center of life* [emphasis added], so that from all sides, everything might run toward my "I" to awaken it, shake it like a tree heavy with fruit, in order to free my soul from all the passing suffering that holds it subjected, confined. My dream is to free it from quotidian life and to fling it upward, forever beyond the earth.[26]

Thus at the center of his paintings—bridge, tree, fruit, flower, Madonna—is found the artist, constant and undeviating in his deepest desire—to find himself. The formal central axis preserves this information through all of the many transformations that Stella conceives:[27] it speaks of Stella's ambition, his desire for recognition "from all sides," his aspiration to transcend the limitations of the finite, his dream of soaring heavenward into the free realm of the spirit. His many stylistic shifts can thus be understood as the artist's struggling search for freedom in a world that seemed to him as hostile as a prison, but also offered him its great joy—the joy of making art.

"The first need of the artist is absolute freedom," Stella wrote. Freed from habit, convention, prejudice, he will be free to search for "il suo proprio io"—his true self.[28]

Notes

1. Stella's range has intrigued other writers. See Joann Moser, *Visual Poetry: The Drawings of Joseph Stella* (Washington, D.C.: Smithsonian Institution Press, 1990), p. 144; Hilton Kramer, "The Other Stella," *Art and Antiques,* January 1989, p. 97; John I. H. Baur, *Joseph Stella* (New York, Washington, London: Praeger Publishers, 1971), p. 18. See also Irma B. Jaffe, *Joseph Stella* (Cambridge: Harvard University Press, 1970), pp. 1–4 and passim, and the revised edition (New York: Fordham University Press, 1988), pp. 1–4.

2. See, for example, Cesare Ripa, *Iconologia.* Padova (facsimile reprint of the 3rd edition, 1603), Hildesheim and New York: George Olmo Verlag, 1970.

3. These papers are now in the collection of the Archives of American Art. See Jaffe (note 1 above), 1970, p. viii; 1988, p. xiv.

4. Field, *The Arts,* October 1921. I interviewed Varèse, Bourgeois, and Mosca between 1963 and 1965.

5. I interviewed Clara Fasano in 1965.

6. Stella intended to write his autobiography and made notes for it shortly before he died. The passage quoted is from notes published in *Art News,* November 1960, under the title of "Discovery of America: Autobiographical Notes."

7. Marinetti is quoted in Joshua C. Taylor, *Futurism* (New York: Museum of Modern Art), p. 124.

8. Frederick C. Howe, *The Modern City and Its Problems* (New York: Charles Scribner's Sons, 1915),

p. 25. A. Giry and A. Reville, *Emancipation of the Medieval Town.*

9. Joseph Stella, miscellaneous notes, translated by the present writer. For the original Italian text, see Jaffe (note 1 above), appendix I, number 17.

10. *Art News,* "Discovery" (note 6 above).

11. Joseph Stella, "Brooklyn Bridge, A Page of My Life," *Transition,* June 1929, pp. 86–88. Stella's *The Bridge* inspired Hart Crane's long poem, "The Bridge." "Through the bound cable strands, the arching path / Upward, veering with light, the flight of strings, — / Taut miles of shuttling moonlight syncopate / The whispered rush, telepathy of wires. / Up the index of night, granite and steel— / Transparent meshes— fleckless the gleaming staves— / Sibylline voices flicker, waveringly stream / As though a god were issue of the strings..." See Jaffe (note 1 above), pp. 245–248.

12. Stella, miscellaneous notes (note 9 above), I, 16.

13. *Art News,* "Discovery."

14. Henry McBride, "Modern Art," *The Dial*, April 1922, pp. 423–424.

15. Stella, miscellaneous notes (note 9 above), I, 20.

16. Moser (note 1 above) speculates that the spiritual content of Stella's art might have some connection with Wassily Kandinsky's thoughts in *Concerning the Spiritual in Art* (1912).

17. Stella, miscellaneous notes (note 9 above), I, 19.

18. Ibid., I, 7.

19. Ibid., I, 21, 31.

20. Ibid., I, 26.

21. Ibid., I, 60. Unlike the other miscellaneous notes, Stella wrote this in English.

22. *New Yorker*, April 18, 1925, p. 17.

23. Stella, miscellaneous notes (note 9 above), I, 8.

24. Ibid., I, 37.

25. An example of how Stella adapted Old Master paintings can be seen by comparing his *Purissima* to Leonardo da Vinci's design for *Leda and the Swan*, now known to us only through a copy by Cesare da Sesto. I wish to thank Professor Yvonne Korshak for drawing my attention to this similarity. Stella was in Barbados in 1938.

26. Stella, miscellaneous notes (note 9 above), I, 45.

27. A strange, difficult, and wonderful book *Gödel, Esher, Bach,* by Douglas Hofstadter, has suggested to me a new way to consider the phenomenon of constancy, symmetry, and balance in the structure of Stella's compositions. Although isomorphism refers to constants that reappear in various transformations within a single work so that they may be said to be self-referential (as in a Bach fugue), I am using the vocabulary to apply not to a single work but to Stella's oeuvre as a whole. I wish to thank my friend David C. Loomis for bringing this book to my attention.

28. Stella, miscellaneous notes (note 9 above), I, 43.

CHRONOLOGY

1877 – June 13, Joseph Stella born in Muro Lucano, a medieval mountain village near Naples. Educated in Muro Lucano and Naples.

1896 – March 1, arrives in New York on S.S. *Kaiser Wilhelm der Grosse,* sponsored by his brother, Dr. Antonio Stella, eminent physician and leader in Italo-American affairs in New York, especially concerned with problems of the immigrants.

1896 – 1897 – Studies medicine and pharmacology, each for about one year.

1897 – Gives up medical studies for painting. Enrolls at the Art Students League.

1898 – 1900 – Attends the New York School of Art, where he comes to the attention of William M. Chase. After one year he wins a scholarship to attend a second year.

1900 – 1905 – Lives on Lower East Side in the Bowery section. Constant sketching of immigrant types, and picturesque and tragic subjects seen on the streets of New York. December 23, 1905, Stella's first published drawings appear in *Outlook,* illustrations for "Americans in the Rough," depicting immigrants at Ellis Island.

1906 – Illustrations for Ernest Poole's novel *The Voice of the Street,* probably done in 1905, as the book was published in 1906.

1907 – To West Virginia. Drawings for *Survey* of the Monongah mine disaster appear in the issue of December 6.

1908 – To Pittsburgh. Drawings of the mining environment appear in *Survey* — January, February, and March 1909.

1909 – Either in this year or possibly 1910 makes his first trip back to Europe. Spends the first year or so in Italy, mostly in Rome, Florence, and Muro Lucano, and possibly Venice. Is friendly with Mancini in Rome.

1911 – 1912 – In Paris. Meets Matisse, Modigliani, Carrà, and probably Boccioni and Severini, among other avant-garde artists. Returns to New York.

1913 – Exhibits two or three paintings in the Armory Show. Has a one-man exhibition at the Italian National Club, 11 West 44th Street, New York.

1914 – Participates in the exhibition of modern art at the Montross Gallery, where his painting *Battle of Lights, Coney Island, Mardi Gras* provokes public derision but wins critical respect in advanced quarters.

1915 – Meets Marcel Duchamp, Picabia, Edgard Varèse, and other artists, writers and musicians who frequent the home of Walter Arensberg.

1916 – 1917 – Moves to Brooklyn where he teaches Italian at a Baptist seminary in Williamsburg.

1918 – To Pittsburgh and Bethlehem. Illustrations for *Survey* of industrial subjects depicting the war effort.

1919 – Exhibits *The Gas Tank* (under the title of *American Landscape*), the first of his major industrial paintings to be shown, at the Bourgeois Galleries.

1920 – Exhibits first *Brooklyn Bridge* painting in his one-man show at the Bourgeois Galleries. Living at 213 West 14th Street. Joins the newly formed Société Anonyme, with directors Katherine Dreier, Marcel Duchamp, and Man Ray. Participates in exhibitions of the Société Anonyme in the 1920s.

1922 – Trip to Naples. Visits Pompeii, Herculaneum, Paestum, Capri.

1923 – Returns to New York. Lives at 451 West 24th Street. January 10, opening of exhibition at the Société Anonyme, where *New York Interpreted* is shown for the first time. August 30, admitted to United States citizenship.

1926 – Travels to Europe. In Naples in September. Possibly visits North Africa.

1928 – In New York, living at 218 East 12th Street. Returns to Europe, this time first to Paris.

1929 – Trip to Naples, January to June. Probably visits North Africa. Returns to Paris. Sometime during 1929 is on the Riviera, possibly near Nice.

1930 – 1934 – Lives in Paris, first at 16 rue Boissonade until late 1933, then at 201 rue d'Alésia. Probable trips to Italy and North Africa during these years.

1934 – February, Stella in Rome during the International Exhibition of Religious Art, in which he shows twelve paintings.

1935 – In New York. Lives at 2431 Southern Boulevard, the Bronx.

1937 – Studio at 322 East 14th Street. December, leaves for Barbados, where he spends several months.

1938 – Travels to Europe. In Paris at 39 Boulevard Edgar Quinet. July 28, in Venice. September, in Naples. By December is back in New York, living at 322 East 14th Street.

1942 – Moves to 13 Charlton Street in April. Gives up studio because of illness and moves to apartment near nephew in Astoria, Queens, at 33-15 Crescent Boulevard.

1943 – Takes studio at 104 West 16th Street. Suffers thrombosis in left eye and returns to Astoria.

1945 – Suffers accident while serving on jury of Third Portrait of America exhibition.

1946 – November 5, Joseph Stella dies.

1
THE BAGPIPERS, 1909
Mixed media on paper
26¼ x 35½ inches
Courtesy of Richard York Gallery, New York City

The Christmas bagpipers are known and loved in Italy and throughout the Mediterranean. Traditionally dressed in short trousers, full jacket and wide cape or short coat, and wearing a tasseled cap and peasant shoes, the bagpipers, shepherds from the countryside, come down into the villages and towns during the holiday season, parading and singing hymns and prayers.

Irma B. Jaffe

Commentaries on the pages facing the color plates
are drawn from manuscript fragments written in Italian
by Joseph Stella and translated by Irma B. Jaffe,
except where indicated.

2
LANDSCAPE AT MURO LUCANO, c. 1910
Oil on canvas, 24½ x 30 inches (oval)
Collection of The Honorable Joseph P. Carroll & Mrs. Carroll,
New York City

I thank the Lord for my having had the good fortune to be born in a mountainous countryside. Light and space are the two essential elements for painting, and the first flights of my timid art emerged in the most free and radiant space and light. My native land, Muro Lucano, in the harsh Basilicata, forced its stubborn roots into the tortured bowels of a rocky hillside. Its houses are built of the living rock and flint...and stand wall to wall...watched over by the battlemented towers of the medieval castle....At its side the mother Church raises its short, stumpy bell-tower, and the echoing of its bell which floods the air with the joyous din of Easter signals the hours of the rosary, and the sad and happy events of daily life.

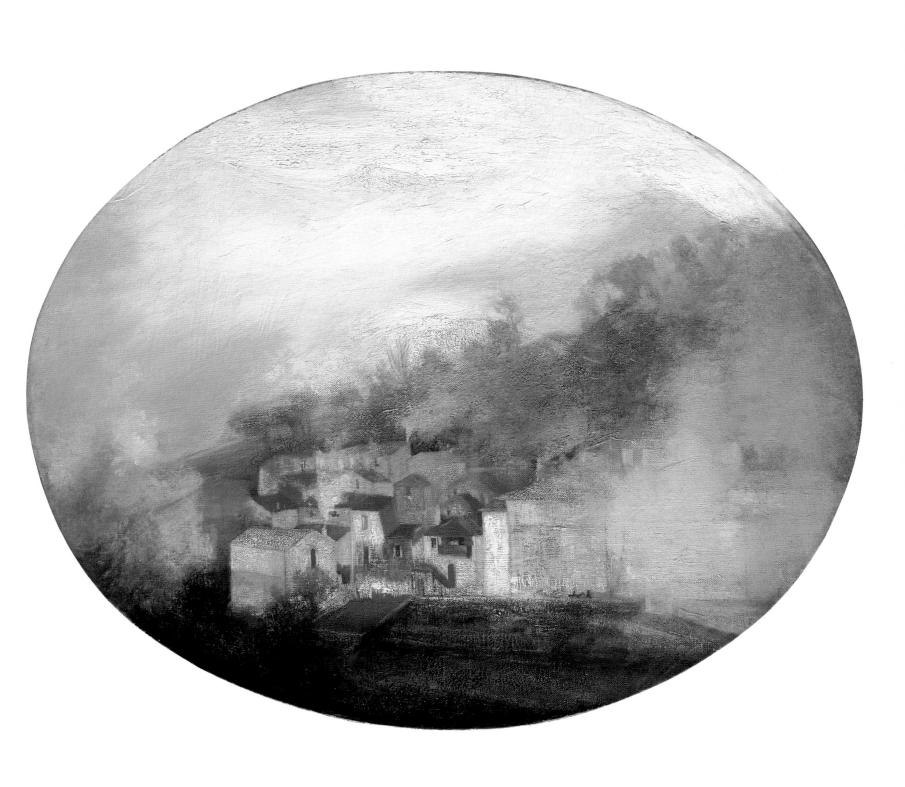

3
BATTLE OF LIGHTS, CONEY ISLAND, MARDI GRAS, 1913
Oil on canvas, 76 x 84 inches
Yale University Art Gallery
Bequest of Dorothea Dreier to the Collection Société Anonyme

I felt that I should paint this subject upon a big wall, but I had to be satisfied with the hugest canvas that I could find. Making an appeal to my most ambitious aims...I built the most intense arabesque that I could imagine in order to convey in an [sic] hectic mood the surging crowd and the revolving machines generating for the first time not anguish and pain but violent, dangerous pleasures. I used the intact purity of the vermilion to accentuate the carnal frenzy of the new bacchanal and all the acidity of the lemon yellow for the dazzling lights storming all around.

Stella, "Discovery of America: Autobiographical Notes"

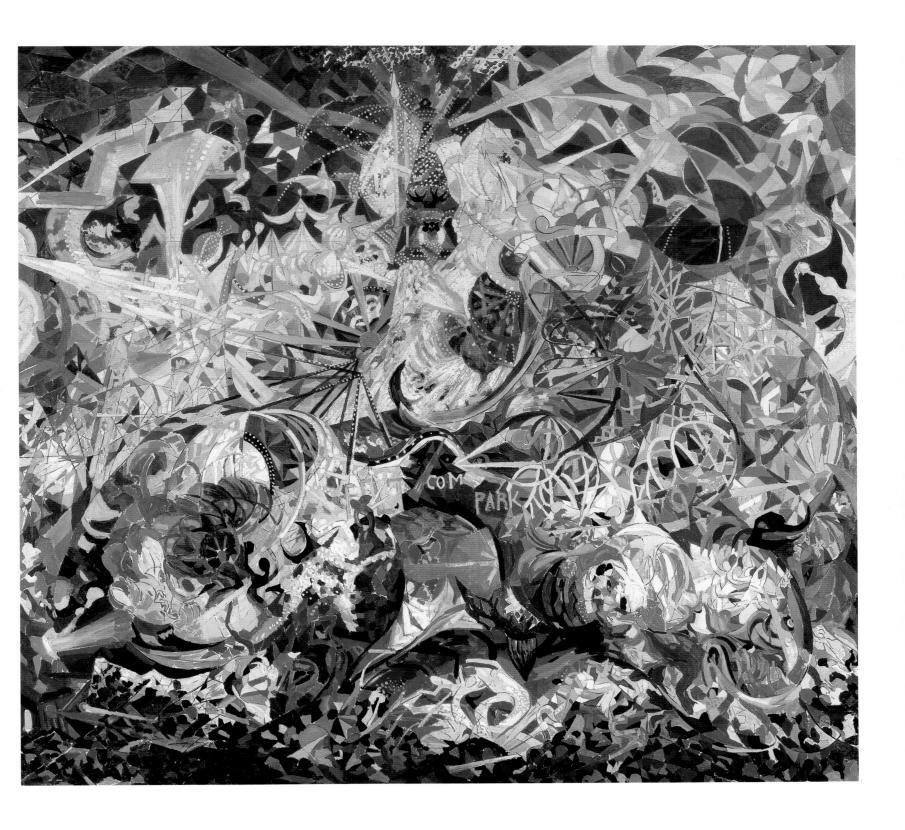

4
SONG OF THE NIGHTINGALE, 1918
Pastel on paper, 18 x 23⅛ inches
The Museum of Modern Art, New York
Bertram F. and Susie Brummer Foundation Fund

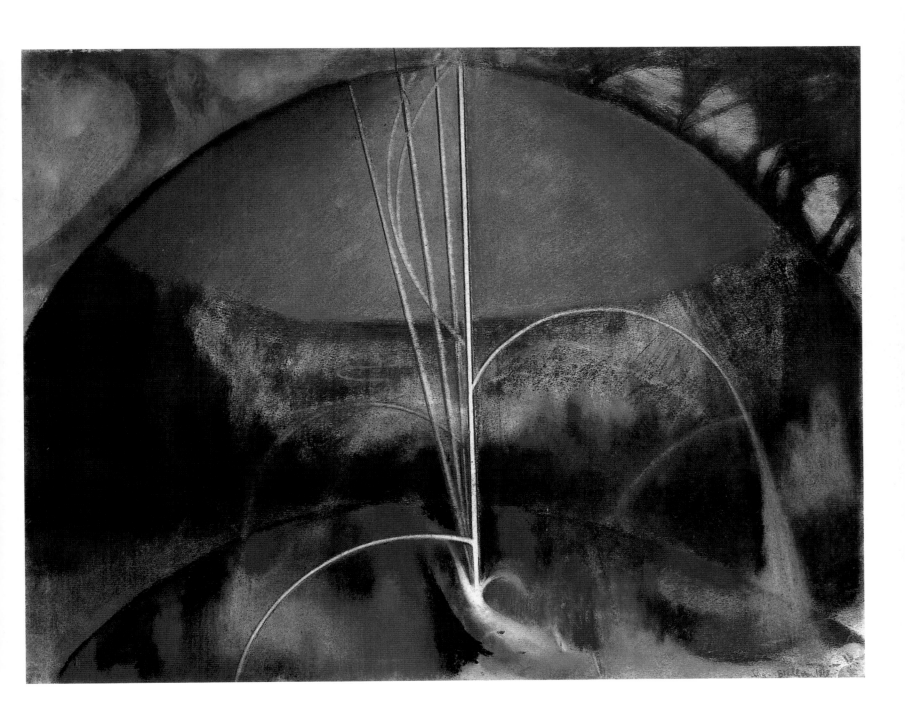

5
LANDSCAPE, 1919
Pastel and charcoal on light blue blotting paper
21⅝ x 16⅞ inches
The Metropolitan Museum of Art
Bequest of Katherine S. Dreier, 1952

Returning to my birthplace...[I find] all of nature smiling like a friend, greeting my arrival with festive salutes. It seems as if flags have bloomed from the window sills for the occasion like the windows in May at the feast of Corpus Domini.

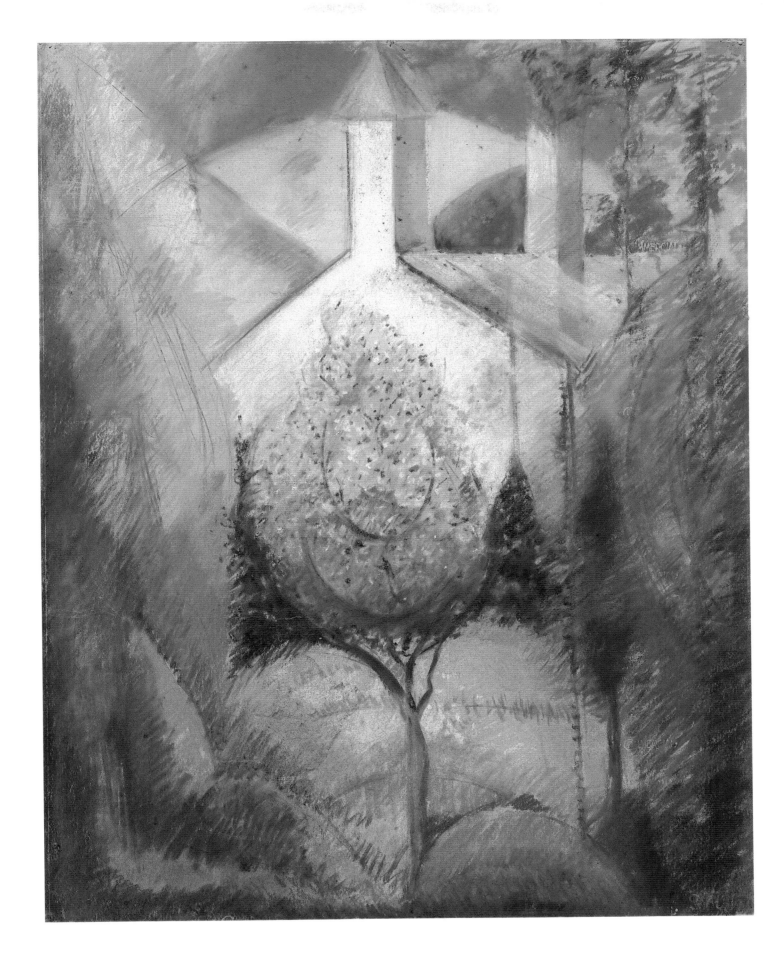

6
NATIVITY, 1919–20
Pastel on paper
37 x 19⅛ inches
Collection of Whitney Museum of American Art
Purchase 31.469

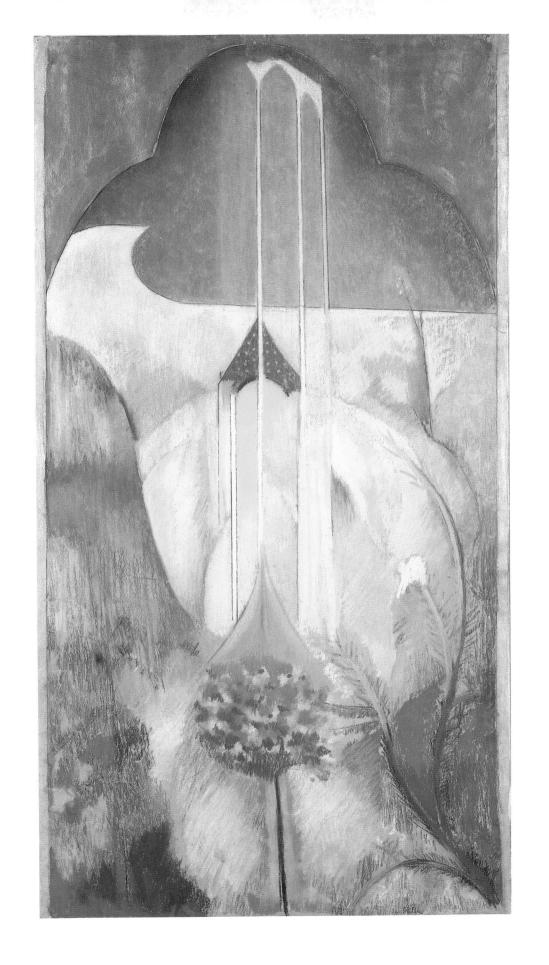

7
A CHILD'S PRAYER, c. 1919
Pastel on paper
23½ x 18¼ inches
Private collection
Photograph: Clive Russ

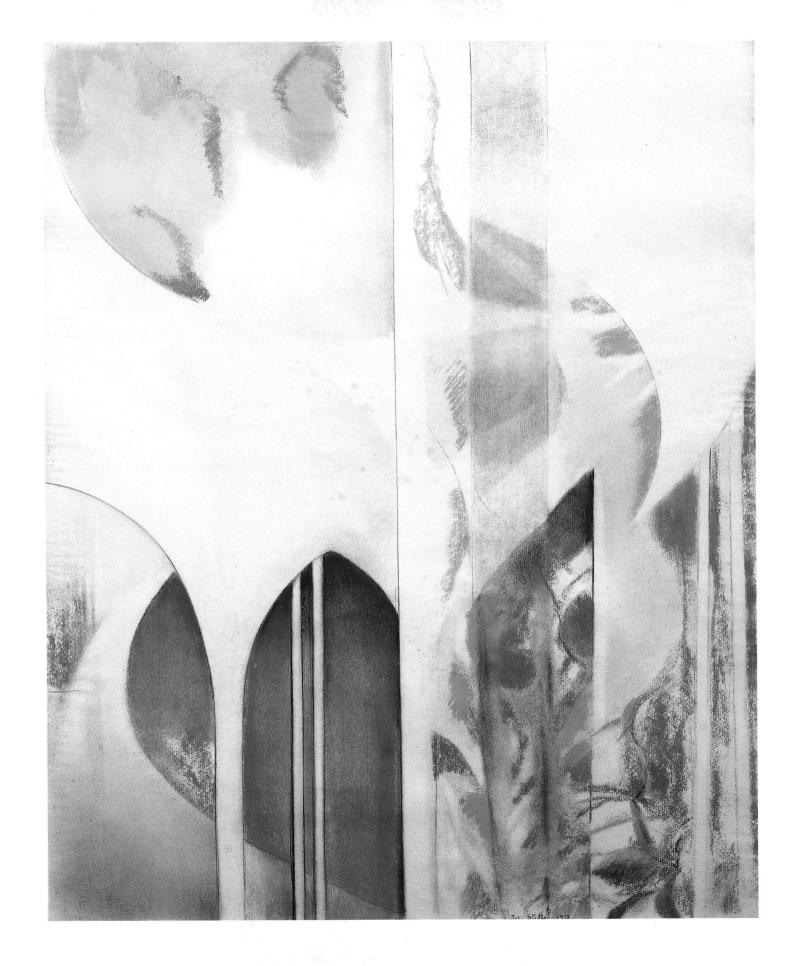

8
BROOKLYN BRIDGE, 1918-19
Oil on canvas, 84 x 76 inches
Yale University Art Gallery
Gift of Collection Société Anonyme

Many nights I stood on the bridge—and in the middle alone—lost—a
defenseless prey to the surrounding swarming darkness—crushed by the
mountainous black impenetrability of the skyscrapers—here and there
lights resembling suspended falls of astral bodies or fantastic splendors
of remote rites, like the blood in the arteries—at times, ringing an alarm
in a tempest, the shrill sulphurous voice of the trolley wires—now and
then strange moanings of appeal from tugboats, guessed more than seen,
through the infernal recesses below—I felt deeply moved, as if on the
threshold of a new religion or in the presence of a new DIVINITY.

Stella: "Brooklyn Bridge: A Page of My Life"

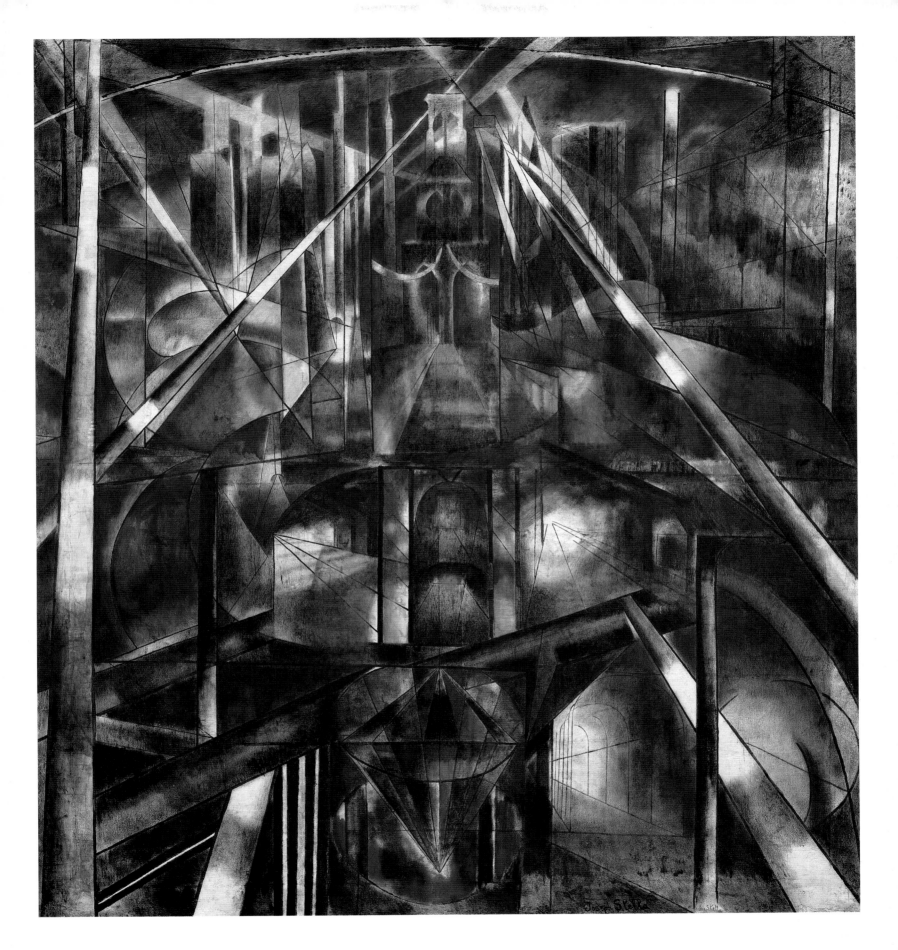

The determination to use all one's powers to forge a gigantic art, limitless... carried out with strict mathematical precision... is realized in the five canvases comprising "NEW YORK." They have been conceived as five movements of a great symphony.

New York... monstrous dream, chimeric reality, Oriental delight, Shakespearian nightmare, unheard of riches, frightful poverty... Alma Mater of the derelict of all the world, your houses, your factories like great treasure chests of booty, your streets like new furrows through fields newly fertilized and tilled, your bridges hang like aerial highways through the chimeric fortunes of the future.

9
THE VOICE OF THE CITY OF NEW YORK INTERPRETED, 1920-22
THE PORT
Oil and tempera on canvas
88½ x 54 inches
Collection of The Newark Museum
Purchase 1937
Felix Fuld Bequest Fund

In "The Port," a series of horizontal lines extend through a kind of infinite latitude. Oblique lines intersect them violently, slashing out zones of color bounding forth in a glaring light or lying quiet in slits of shadows.... Against the deep blue-green that dominates the sky and water like a triumphant song of a new religion, there rises the pure cylindrical forms of the smoke stacks... the trees of the ship and factory forest... while the black telegraph wires dart like needles through space, knitting together the far and the near in harmonious unity, vibrant with love.

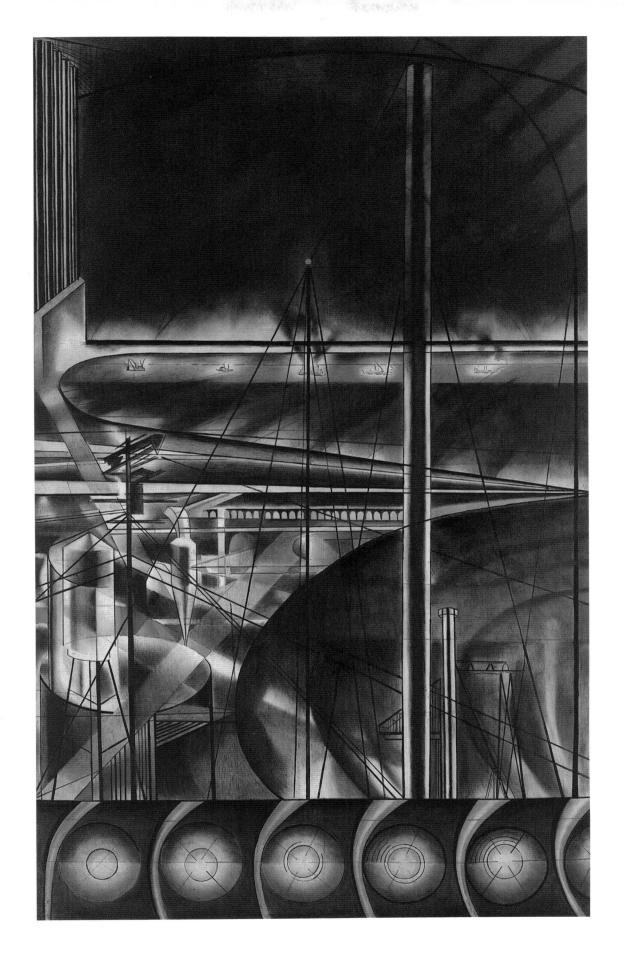

10
THE VOICE OF THE CITY OF NEW YORK INTERPRETED, 1920-22
THE WHITE WAY I
Oil and tempera on canvas
88½ x 54 inches
Collection of The Newark Museum
Purchase 1937
Felix Fuld Bequest Fund

The "White Ways" at each side [of "The Skyscrapers"] churn with dazzling splendor: they look like monstrous wings of fantastic butterflies. Broadway—the White Way…noisy and shrill, wild and aflame with pleasure-seeking.

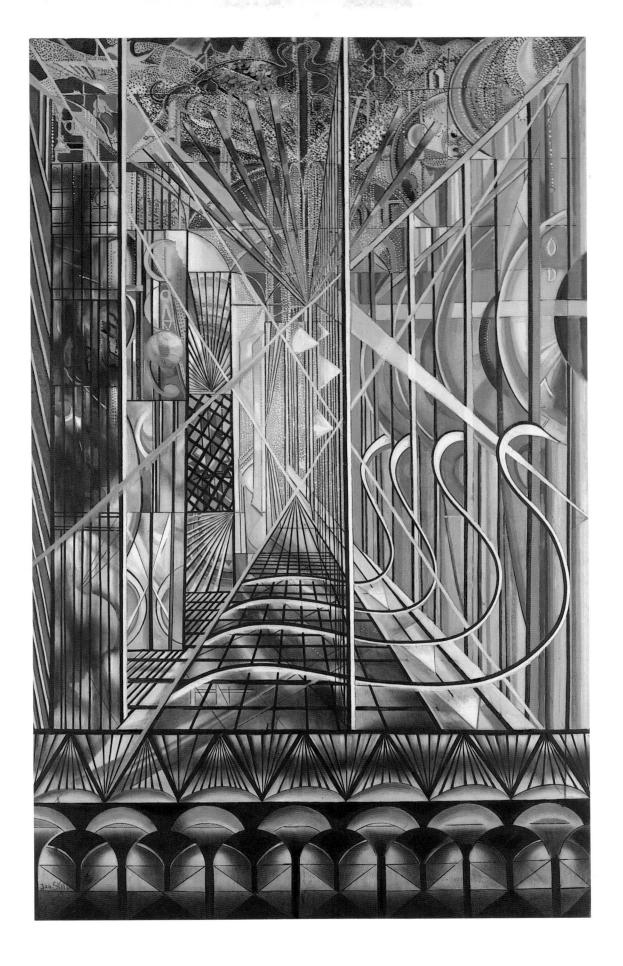

11
THE VOICE OF THE CITY OF NEW YORK INTERPRETED, 1920-22
THE SKYSCRAPERS
Oil and tempera on canvas
99¾ x 54 inches
Collection of The Newark Museum
Purchase 1937
Felix Fuld Bequest Fund

When fog obliterates the bases of the skyscrapers they seem suspended
in air.... At the top, searchlights trace the prophecy of the WAY OF
THE FUTURE, while at the base...converging at the center like a prow,
the clangor of a silvery light breaks out vehemently...

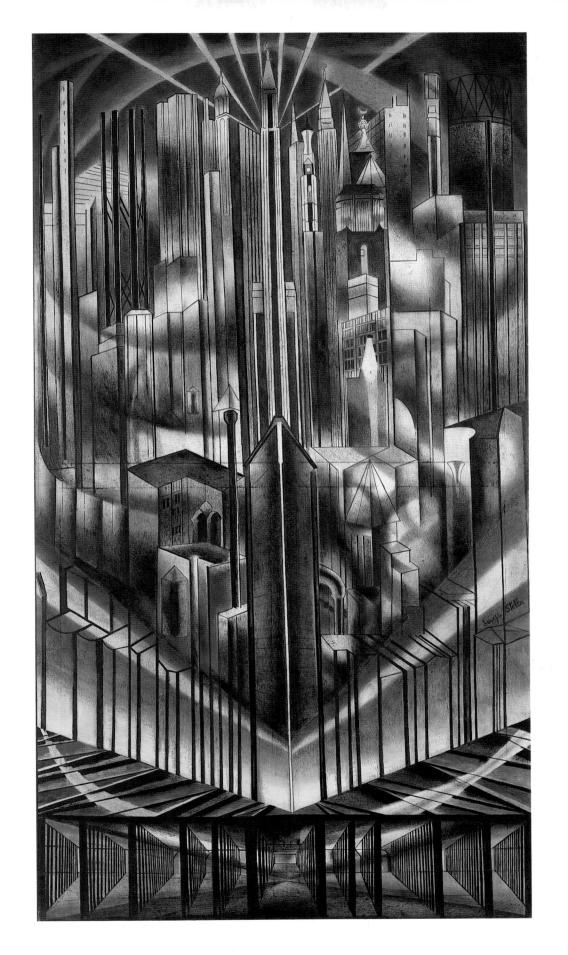

12
THE VOICE OF THE CITY OF NEW YORK INTERPRETED, 1920-22
THE WHITE WAY II
Oil and tempera on canvas
88½ x 54 inches
Collection of The Newark Museum
Purchase 1937
Felix Fuld Bequest Fund

The multicolored, flashing lights of the billboards create a new song
of celebration.

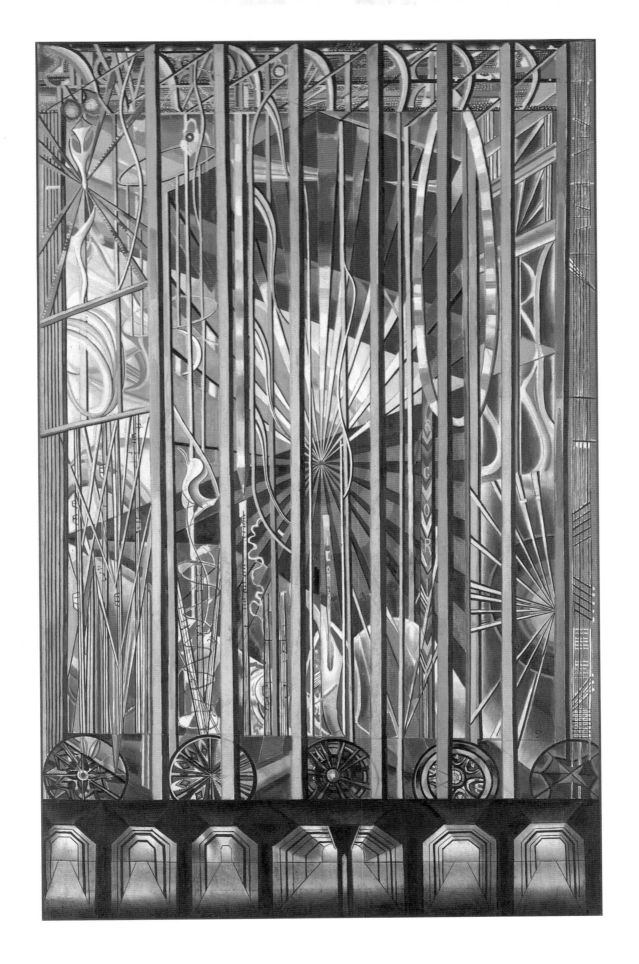

13
THE VOICE OF THE CITY OF NEW YORK INTERPRETED, 1920-22
THE BRIDGE
Oil and tempera on canvas
88½ x 54 inches
Collection of The Newark Museum
Purchase 1937
Felix Fuld Bequest Fund

Seen for the first time, as a weird metallic Apparition under a metallic sky, out of proportion with the winged lightness of its arch, traced for the conjunction of Worlds, supported by the massive dark towers dominating the surrounding tumult of the surging skyscrapers with their gothic majesty sealed in the purity of their arches, the cables, like divine messages from above, transmitted to the vibrating coils, cutting and dividing into innumerable musical spaces the nude immensity of the sky, it impressed me as the shrine containing all the efforts of the new civilization of America...the eloquent meeting point of all the forces arising in a superb assertion of powers, in Apotheosis.

Stella: "Brooklyn Bridge: A Page of My Life" (Privately printed as a brochure, this text accompanied illustrations of the five New York Interpreted paintings. It was later published in Transition, *nos. 16-17 (June 1929).*

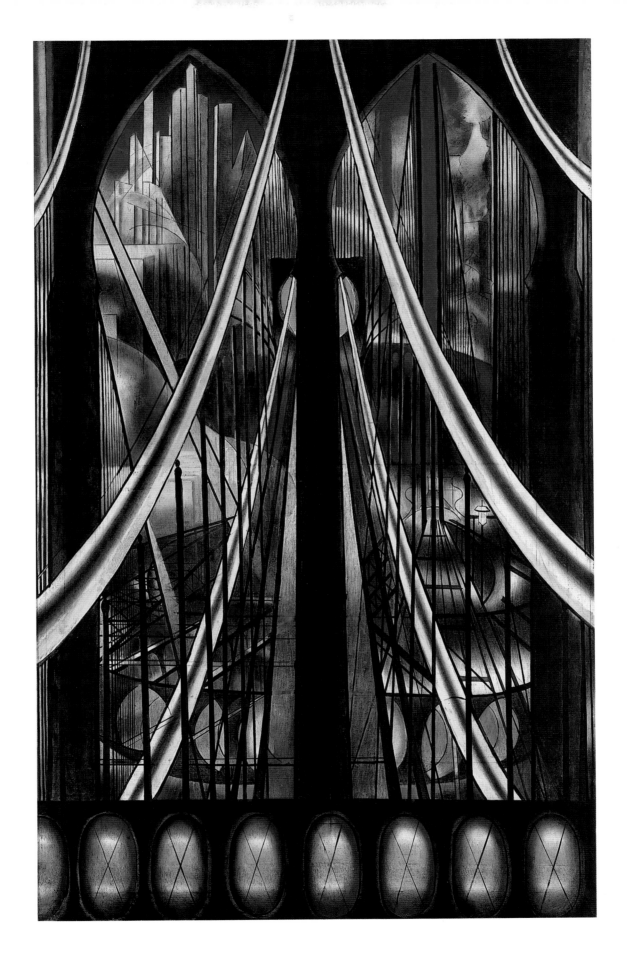

14
TREE OF MY LIFE, 1919
Oil on canvas
83½ x 75½ inches
Collection of Mr. and Mrs. Barney A. Ebsworth

[While working on the "Brooklyn Bridge"], brusquely, a new light broke over me, metamorphosing aspects and visions of things. Unexpectedly, from the sudden unfolding of the blue distance of my youth in Italy, a great clarity announced PEACE . . . proclaimed the luminous dawn of A NEW ERA.

 Upon the recomposed calm of my soul a radiant promise quivered. And one clear morning of April I found myself in the midst of joyous singing and delicious scent, the singing and the scent of birds and flowers ready to celebrate the baptism of my new art, the birds and flowers already bejeweling the tender foliage of the newborn tree of my hopes,
"The Tree of My Life."

Stella: "Brooklyn Bridge, A Page of My Life"

The pure cobalt with which our sky is covered lovingly protects and encloses, at the upper part of the canvas, the whiteness of the flowers that close off the last arduous flight of the Spiritual Life. And the pure beauty of our homeland . . . transformed, ennobled by the nostalgia of memories, flows all around like healthful air, joyfully animating the sumptuous floral orchestration that follows the episodes of the ascension with appropriate resounding chords: the clanging of silver and gold, signifying the first triumphs, and the deep adagio, played by the charged, rich greens and reds, loosened from the sudden searing cry of the intense vermilion of the lily, placed as a seal of generative blood at the base of the robust trunk, twisted, already twisted by the first fierce struggles in the snares that Evil Spirits set on our path.

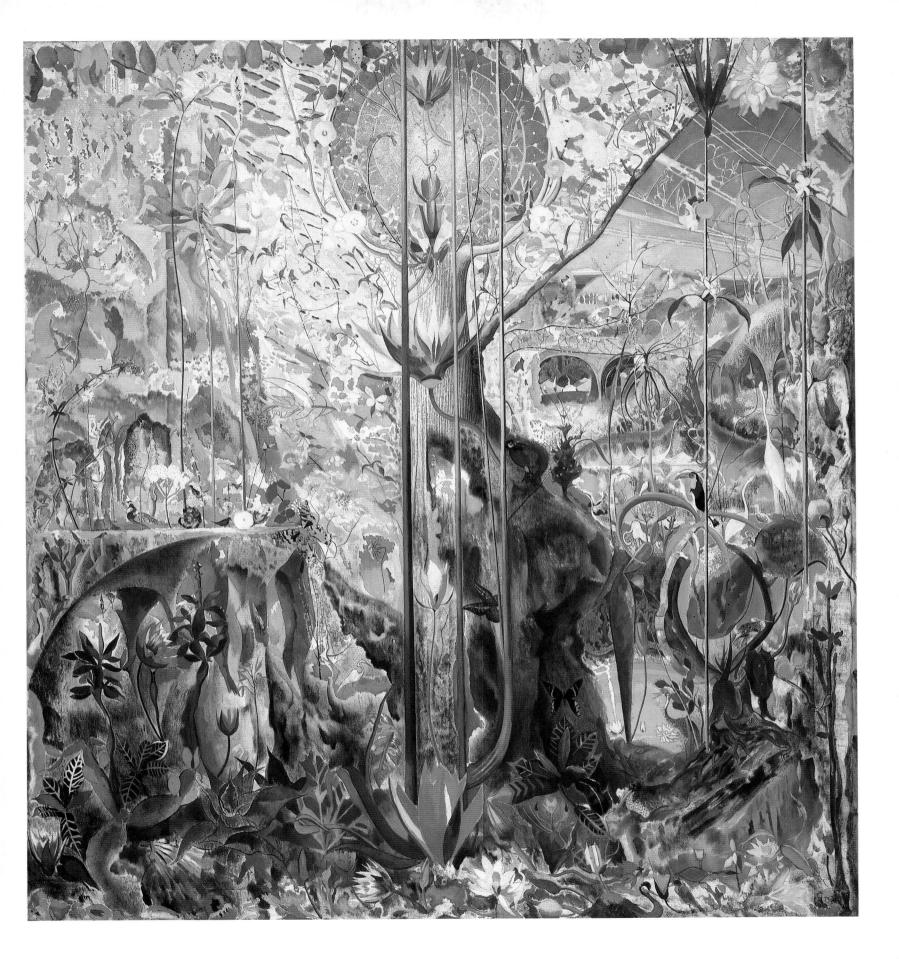

15
THE APOTHEOSIS OF THE ROSE, 1926
Oil on canvas, 84 x 47 inches
Iowa State Education Association
Des Moines, Iowa

May, shining and filled with the sounds of warbling,
Proclaims its arrival with the vermilion bursts of joy
Radiating from the center of the canvas like

A Heart.
The clear serenity of the sky offers as an altar
The Queen of Heaven
With a silver Halo, the song that foretells the Mystic Dawn.
And from the base of the canvas arises, fluttering—propitious
 votive offering—
A dewy thicket of small roses and field flowers
Set in snowy whiteness.
The whiteness of two herons springs as if by magic out of the
 shining brook that echoes with heavenly resonance,
The brook toward which rush other birds, to bathe themselves
In the blue and the light,
To draw fresh energy for their joyous voices that they may
 strengthen, render more fully
The ringing Chorus of Praise
Celebrating the divine union
 of Sky and Earth
As they sing in unison.

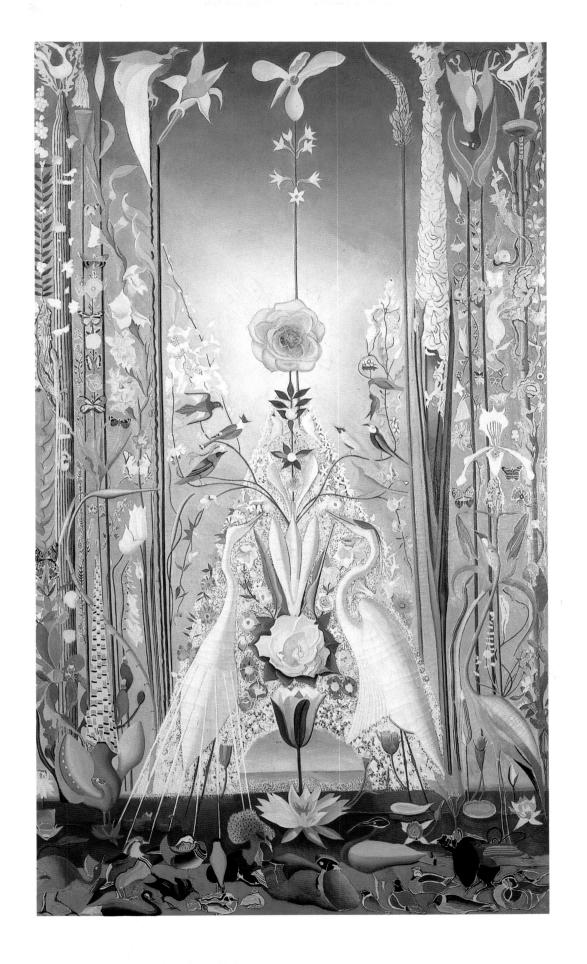

16
VIRGIN OF THE ROSE AND LILY, c. 1926
Oil on canvas, 57½ x 44¾ inches
Courtesy of The Snite Museum of Art, University of Notre Dame
Collection of The Honorable Joseph P. Carroll and Mrs. Carroll,
New York City

I remember the bursting out of art in my childhood. It was like a sudden flash of light, thunderous as some celestial torrent—and my poor soul, overwhelmed, trembled like one of those slender stalks in the furious explosion of an autumnal golden sunset, atop one of my mountains. My soul leaped with joy, as at the unexpected discovery of a real treasure, the treasure of the Holy Friend, the consolatrix whom I must always have loved, and who must always have been smiling upon me, strewing with roses the path of my life. And overflowing like a vase, I thrilled with the secret delight of one who knows that for him alone there exists an eternal fountain of joy.

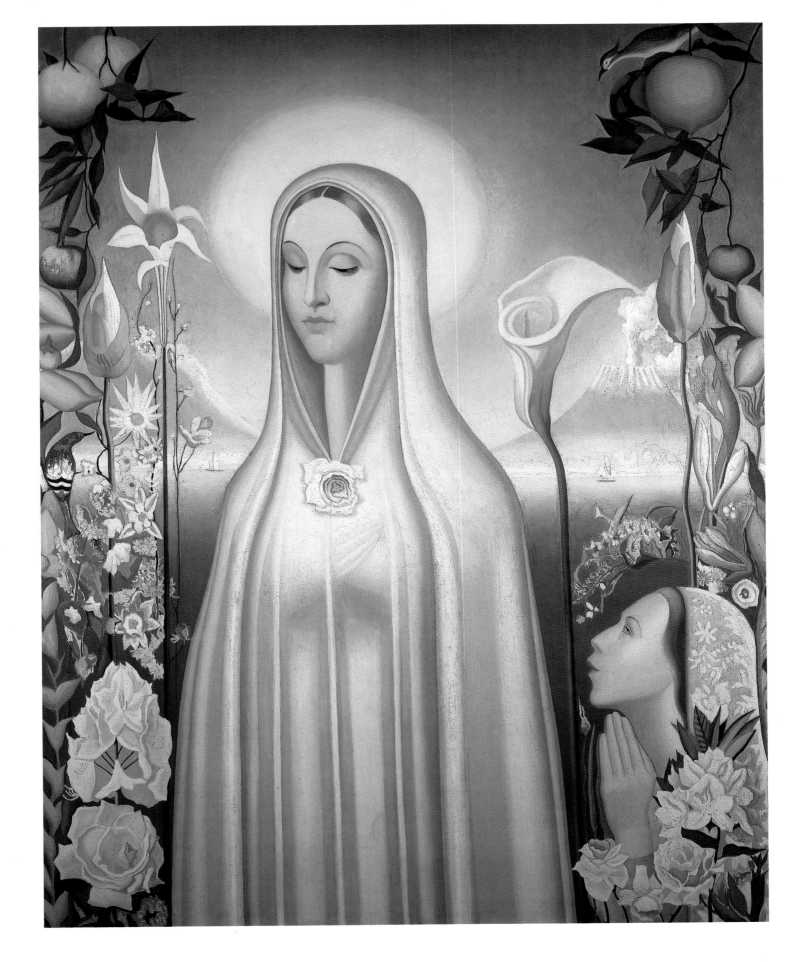

17
THE VIRGIN, 1922
Oil on canvas
39⁹/₁₆ x 38¾ inches
The Brooklyn Museum
Gift of Adolph Lewisohn, 28.207

[Stella was overwhelmed by Piero della Francesca's "Duchess of Urbino." His description of that painting suggests its influence on "The Virgin."]

On her head she wears sumptuous yet restrained adornments—a jeweled crown, emblematic of fabulous wealth, dominates the top of the head and reminds one of some strange vegetation that flowers on a hillside. The face...stands out as if cut with diamond-like precision, set in the blue sky like a radiant Host.

The perfect line of the skull and forehead is curved and flows without interruption to define with exultant eloquence the character of the slightly curved nose and the mouth that suggests thoughts of misfortune...the rounded chin is like a child's and, related to the strong contours of the long, rounded neck, remains youthful...

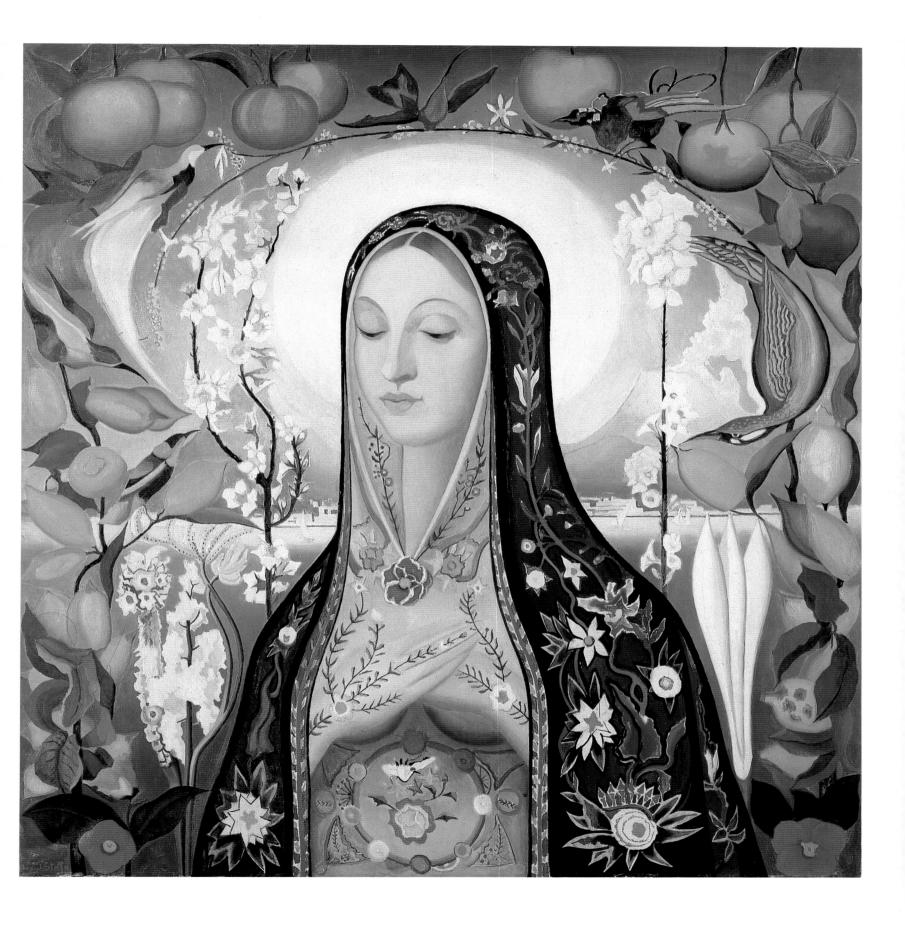

18
MATER DEI, c. 1926
Oil on canvas
38¾ x 38¾ inches
Courtesy of Snyder Fine Art, New York City

Gold
Vermilion
Green
Blue
Encircled by the intense GOLD of the Aureole the purple of her
mantle is illuminated with the tonality of sunset—her mantle,
embroidered with Gold at the sides, and decorated with floral arabes-
ques at the center, becomes Vermilion inside the deep Green of the bodice,
framing with mystic blood the MATERNAL GESTURE OF DEDICA-
TION AND PROTECTION of her hands which uncover the breast
of the LIVING FOUNTAIN.

 And dramatically foreshadowing the DRAMA of the CHILD's fate—
whose fortunate birth into LIFE is announced by the joyous chorus of
the chirping flowers—the BLUE swaddling cloth, decorated with stars
and bands, holds him close, like a talisman.

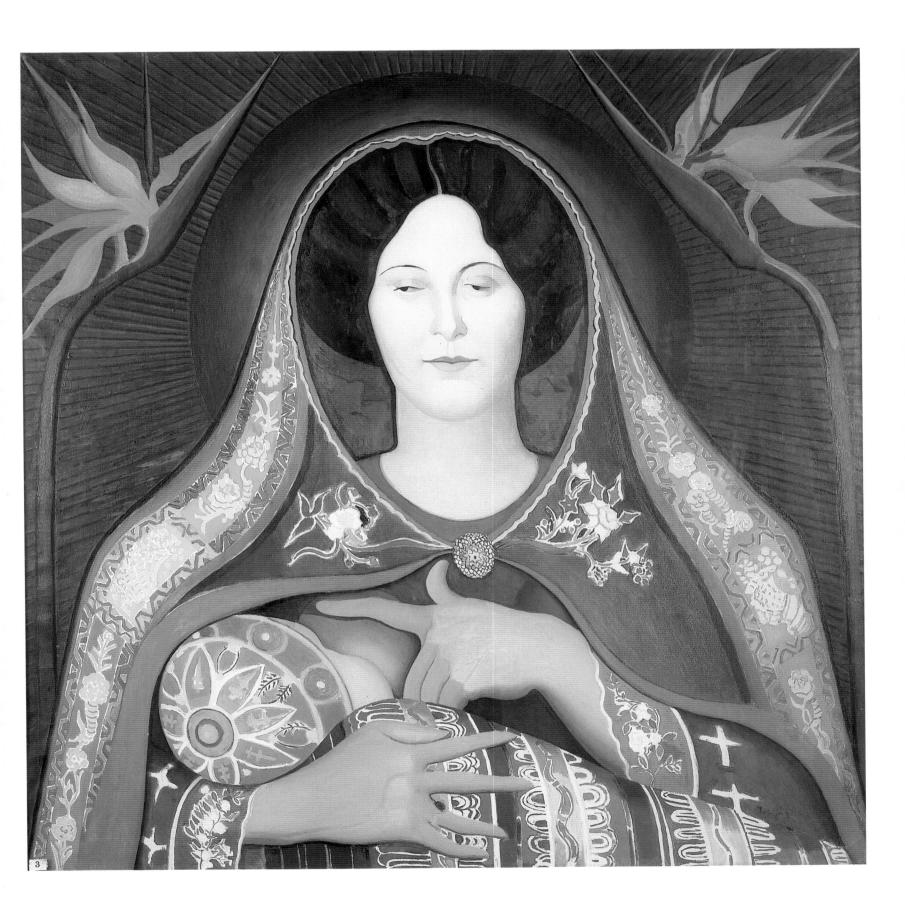

PURISSIMA, c. 1926
Oil on canvas
76 x 57½ inches
Courtesy of Snyder Fine Art, New York City

Blue	White
Violet	Silver
Green	Rose
	Yellow

Clear morning chanting of Spring.

BLUE intense cobalt of the sky—deep ultramarine of the Neapolitan sea, calm and clear as crystal—and alternating with zones of light blue, the mantle multicolored (an enormous lily blossom turned upside down).

SILVER quicksilver of spring water, quilted with the rose green and yellow of the gown—greenish silver, very bright—mystic DAWN-white—of the Halo.

WHITE as snow for the two herons, whose gleaming white necks enclose, like a sacred shrine, the prayer of the VIRGIN.

YELLOW very light—for the edges of the mantle—to bring it out clearly with diamond purity, and reveal the hard firm modeling of the virginal breast. The lines of the mantle fall straight over the long hieratic folds of the gown, forming a frame—and the full, resonant yellow of unpeeled lemons at both sides of the painting are like echoing notes of the propitious shrill laughter of SPRING.

VIOLET mixed with ultramarine for the zigzag motif in the panel along the edge of the mantle, and bright, fiery violet at the top of Vesuvius, near the white fountainhead of incense—light violet tinged with rose, for the distant Smile of Divine Capri.

GREEN soft, tender, like new grass—intense green for the short pointed leaves that enclose the lemons—and a dark green, both sour and sweet, for the palms that fan out at the sides like mystic garlands.

PINK strong—rising to the flaming, pure vermilion borders—of the Rose, brilliant as a jewel, in contrast to the waxy pallor of the hands clasped in prayer—and infinitely subtle, delicately modulated rose for the small flowers that with the others of various colors weave out of dreams and promises the splendid bridal gown of the "Purissima."

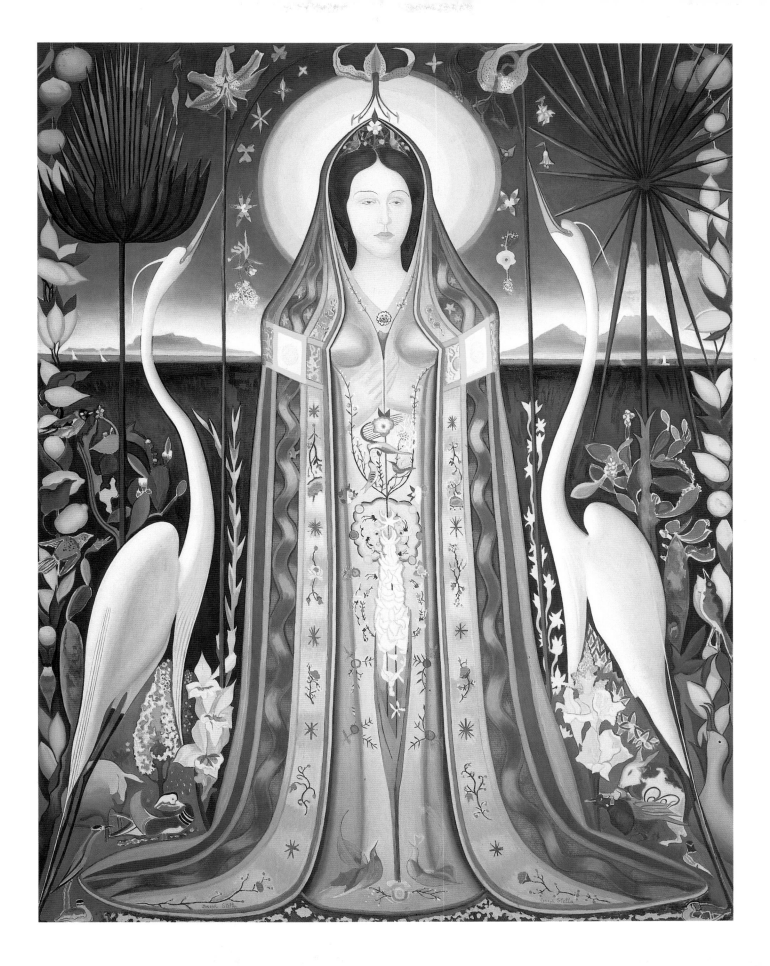

20
THE BIRTH OF VENUS, 1922
Oil on canvas, 85 x 53 inches
Iowa State Education Association
Des Moines, Iowa

The first idea of painting Venus suddenly occurred to me when I was struck by this verse of Anacreon: Who did sculpt the blue sea? Instantaneously a terse blue sea expanded in front of me. It arose in an apotheosis culminating in the radiant form of Venus. I was shaken with joy as if I had suddenly discovered a treasure long sought for. Thrilled by the idea of possession, I was assaulted by a violent desire quickly to realize this idea in painting for my joy, and for the joy of others. But long and difficult is the road leading to conquest....

With the painstaking zeal of the true lover I tried every means to render my artistic ability worthy of the arduous task....

[At last] Venus arose in all the glory of her prime....I gave her a distant look...and I put two birds (symbols of the flight and the singing of Love) upon her arms....And as ministers presiding and officiating on a feast day, I imagined the fishes...as seraphs playing the music of their gliding movements...on both sides of their Goddess.

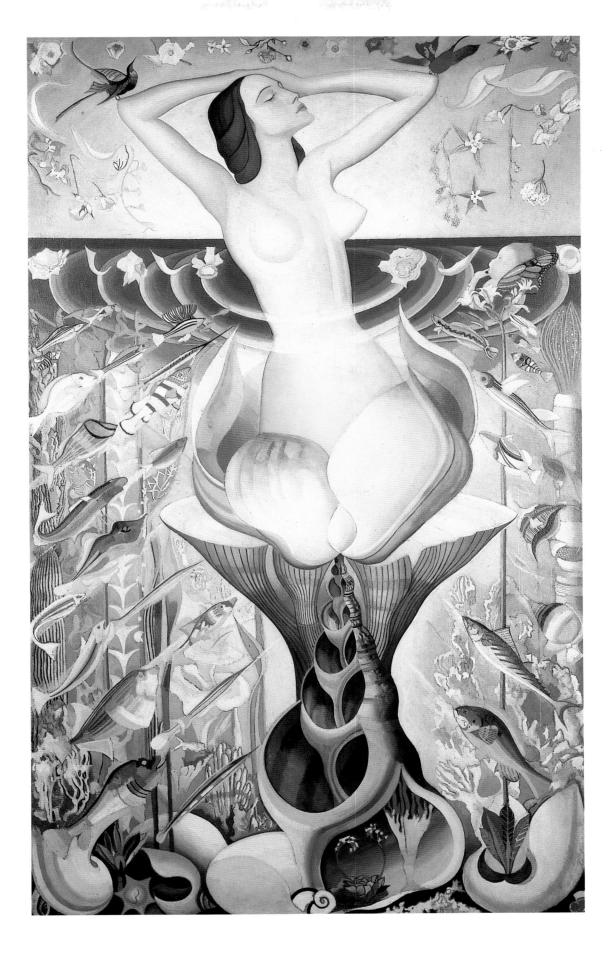

21
LEDA AND THE SWAN, 1922
Oil on canvas
42½ x 46½ inches
Courtesy of the Spanierman Gallery, New York City

The Myth of Leda is the myth of creation, of joyous, ardent creation, blowing its divine breath into the wind and sun. The act is pure and simple, without pretext or pretense...and it is sanctified, raised high, as a spur and example to human beings. The urgent need of fecundation, a kind of christening from which we are born in new splendor, arises, ascends and is framed, set in the purest realms of the clearest blue heaven. Creative energy is clean and chaste, symbolized by the shimmering white of the swan which flings itself upon her as if upon an altar, to perform its rite upon the full golden, incorruptible body of the goddess of fertility.

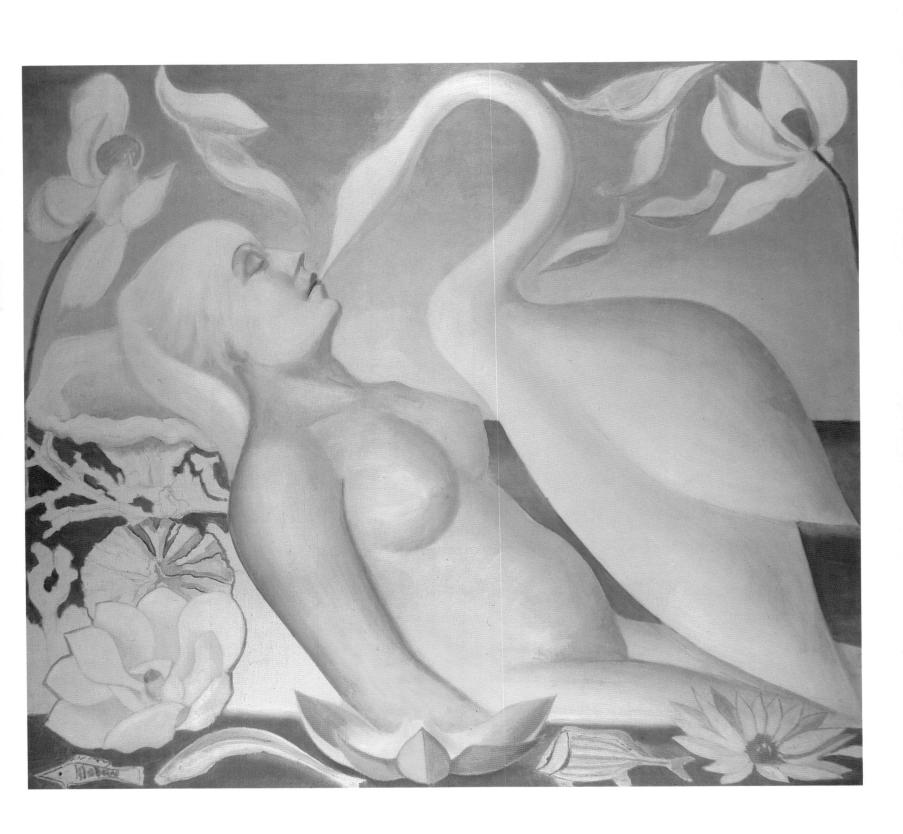

22
TROPICAL FLOWERS, c. 1922
Oil on canvas
25½ x 21½ inches
Courtesy of Richard York Gallery, New York City

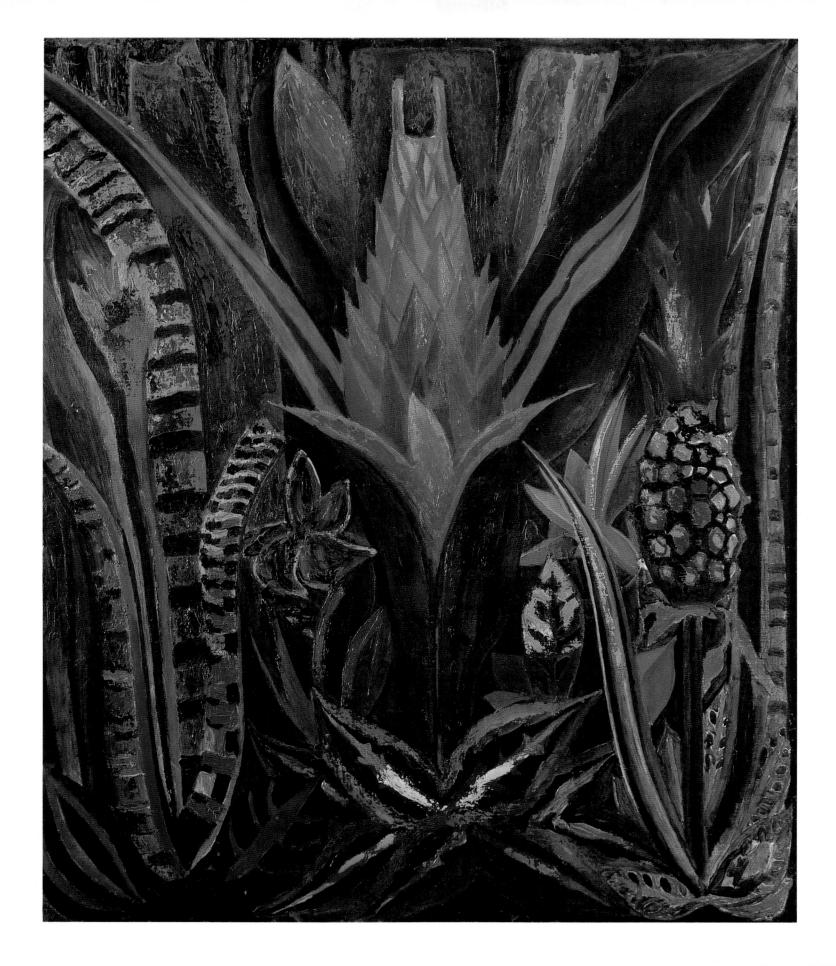

23
NEAPOLITAN SONG, 1929
Oil on canvas
38½ x 28¼ inches
Collection of Harvey & Francoise Rambach

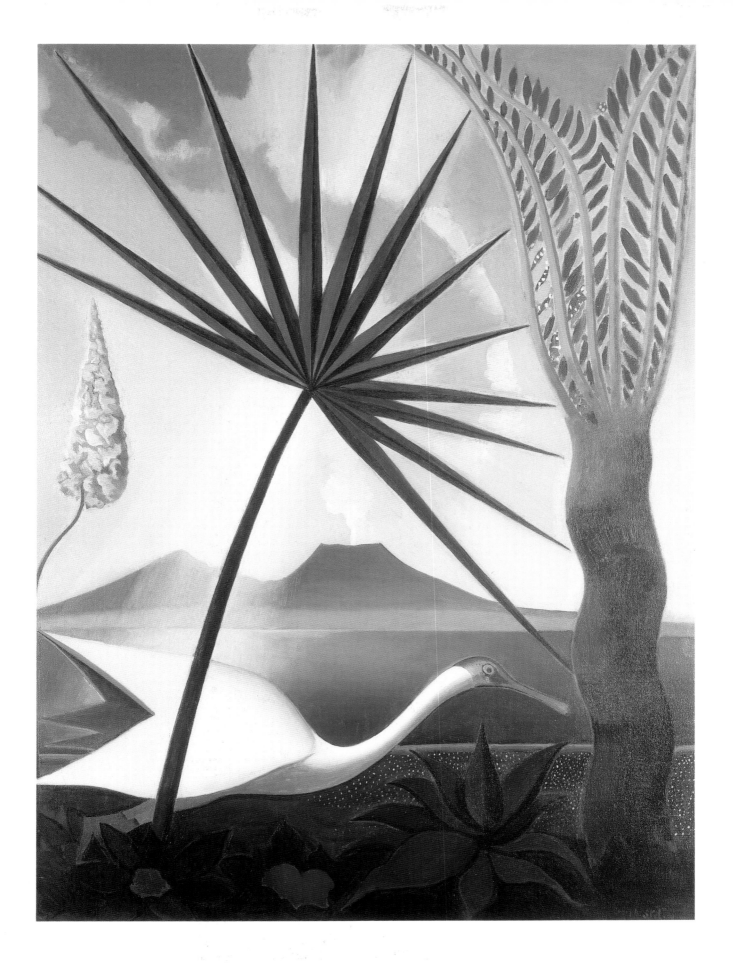

24
LOTUS, n.d.
Oil on canvas
14⅞ x 11 inches
Courtesy of Richard York Gallery, New York City

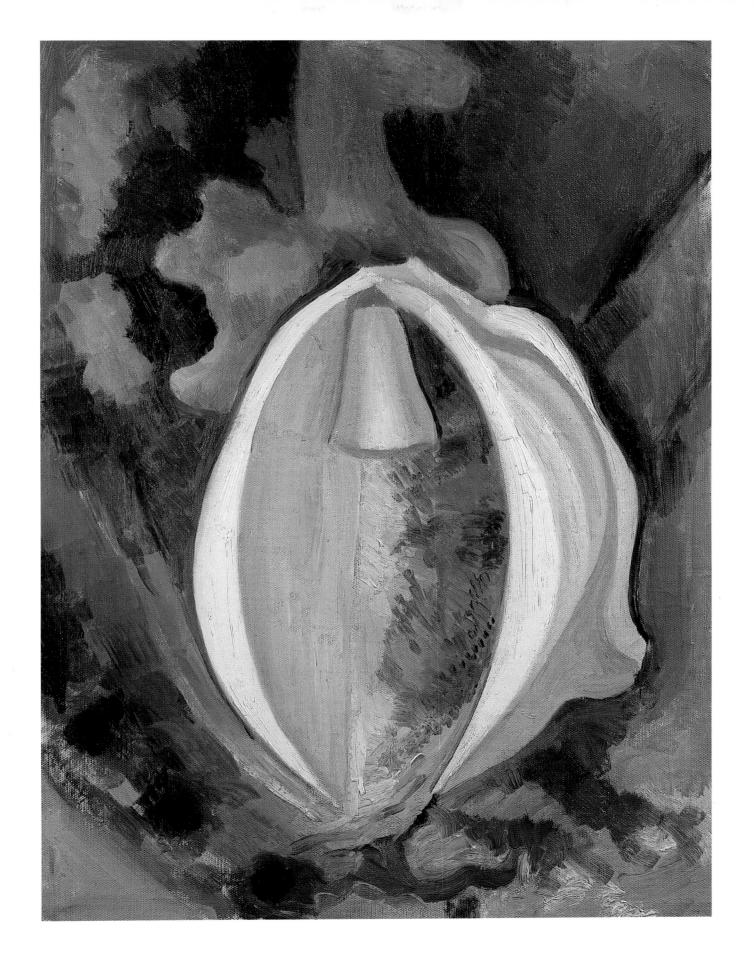

25
STILL LIFE (QUINCE), n.d.
Oil on canvas
8¾ x 10¾ inches
Courtesy of Richard York Gallery, New York City

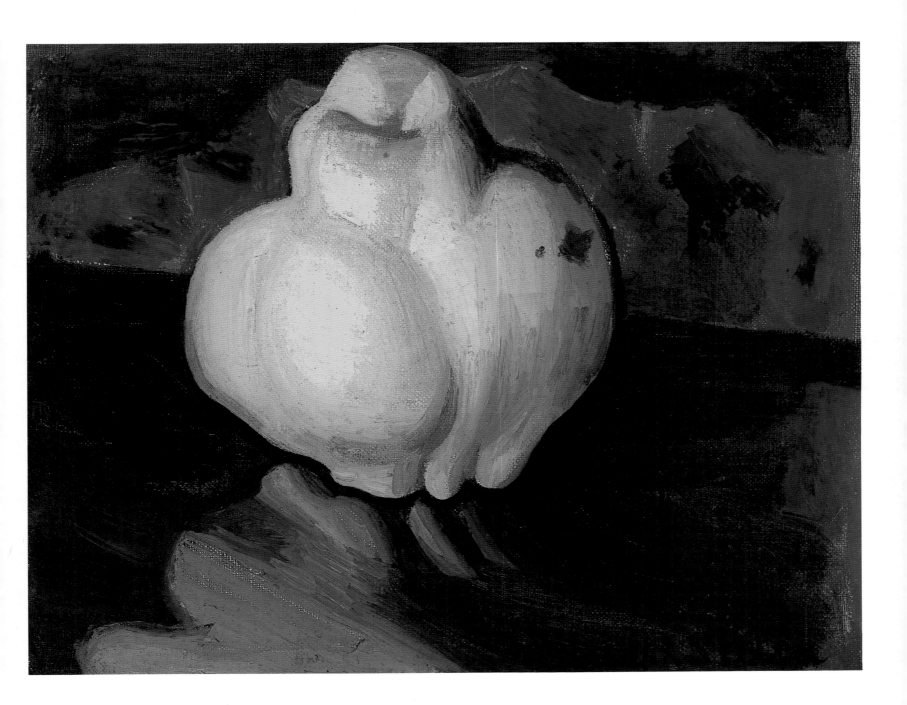

26
EGGPLANT, n.d.
Crayon on paper
20½ x 16 inches
Courtesy of Richard York Gallery, New York City

From the tree of my blossoming life, fragrant with flowers and melodious birds singing the psalm of spiritual joy, suddenly there arose without warning, sharp-pointed and thorny, the first fruits of sensuality—harsh, bitter, yet filled with wild and delicious perfume....

Desire erupted imperiously, its demands sharper and more cutting with each day. It claimed the immediate gratification of its needs....In the sleepless nights, like smoldering timber, like an eternal flame, I burned with the vision of virgin breasts, firm as a glistening crystal globe, pink, tempting...I sharpened the knife of my violent desire which cut and opened them like mysterious fruit, feeling in that moment a spasmodic voluptuousness of relief and liberation.

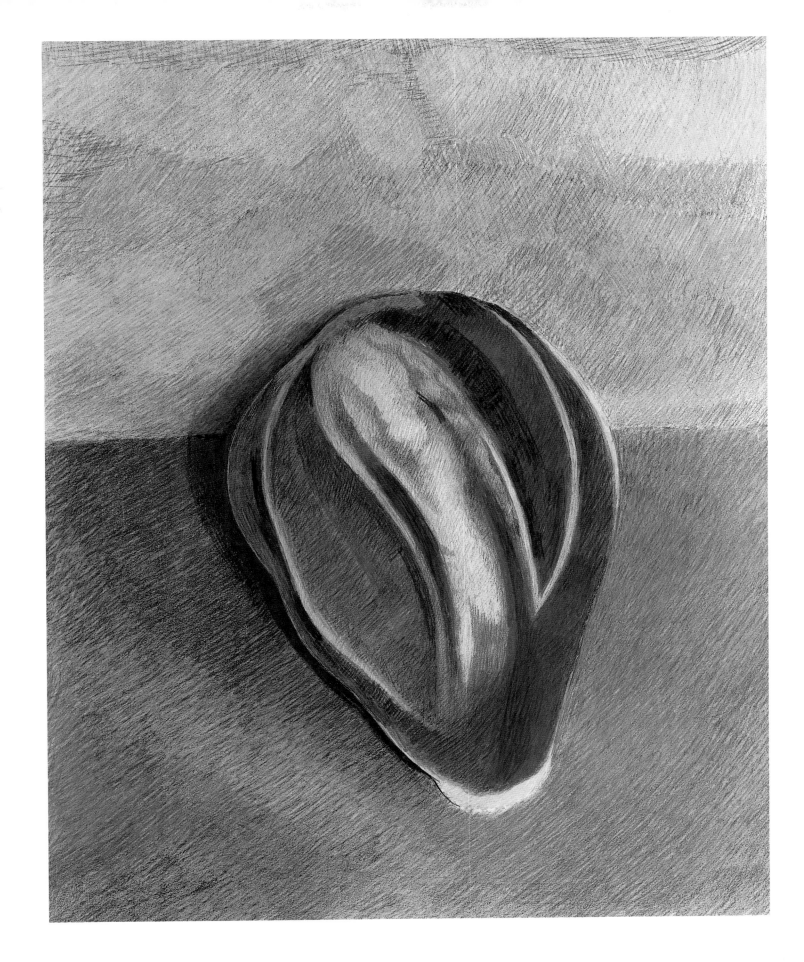

27
FLAMINGO, n.d.
Oil on canvas
51 x 38¼ inches
Courtesy of Snyder Fine Art, New York City

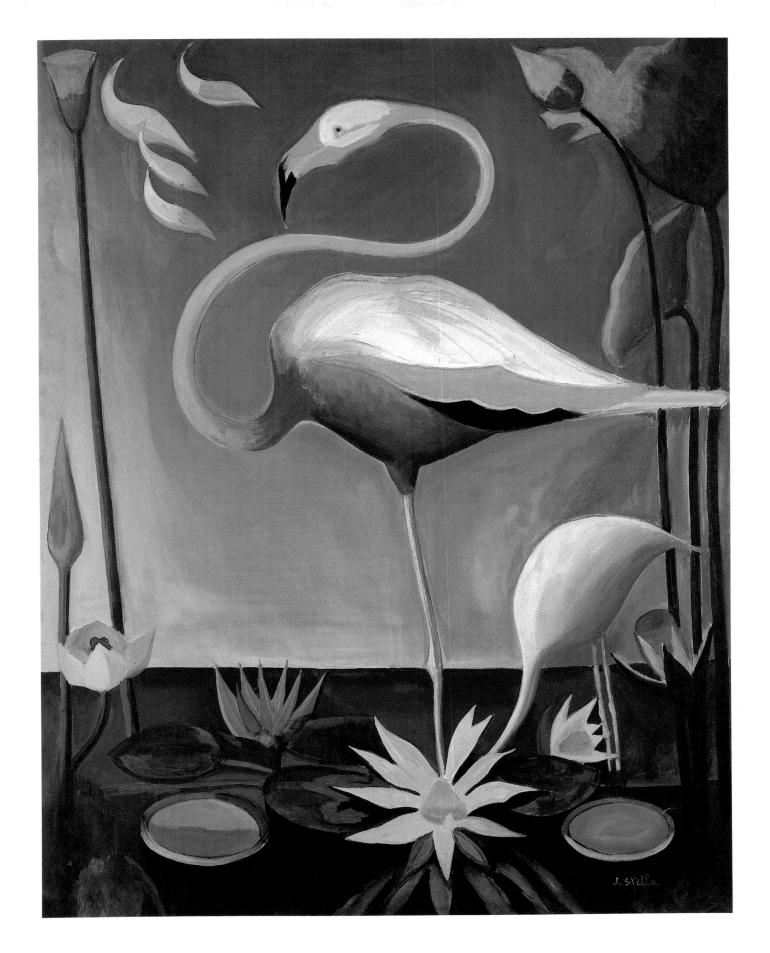

28
THE PALMS (HERONS), 1926
Pastel on paperboard
43½ x 32⅝ inches
Hirshhorn Museum and Sculpture Garden
Smithsonian Institution
Gift of Joseph H. Hirshhorn, 1966
Photograph: Lee Stalsworth

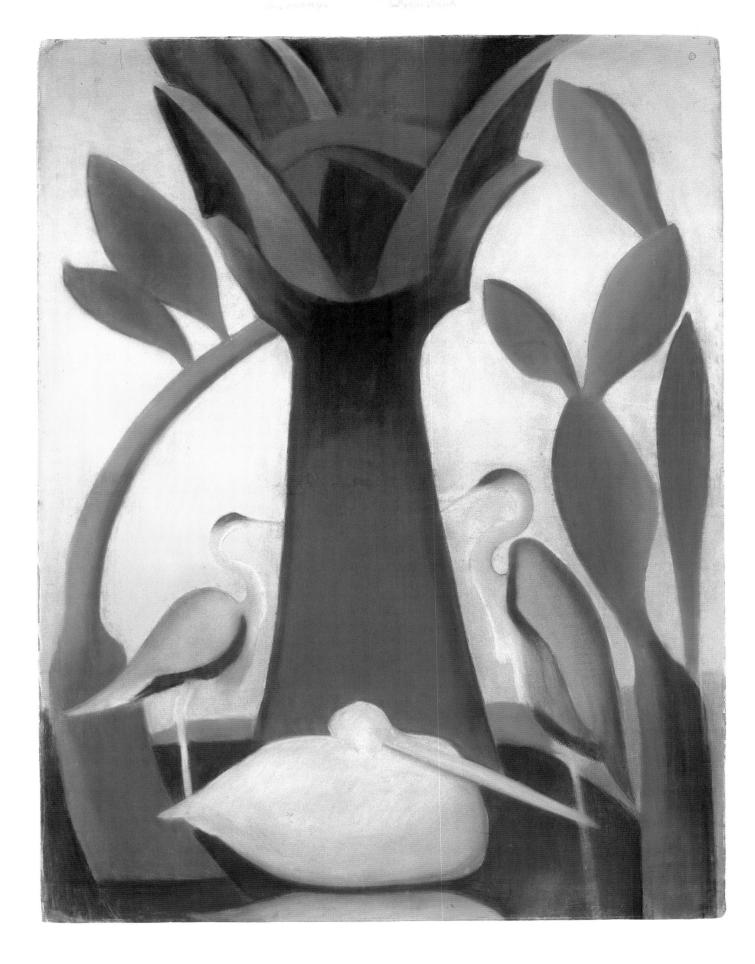

29
FULL MOON, BARBADOS, c. 1940
Oil on canvas
36 x 34 inches
Courtesy of Richard York Gallery, New York City

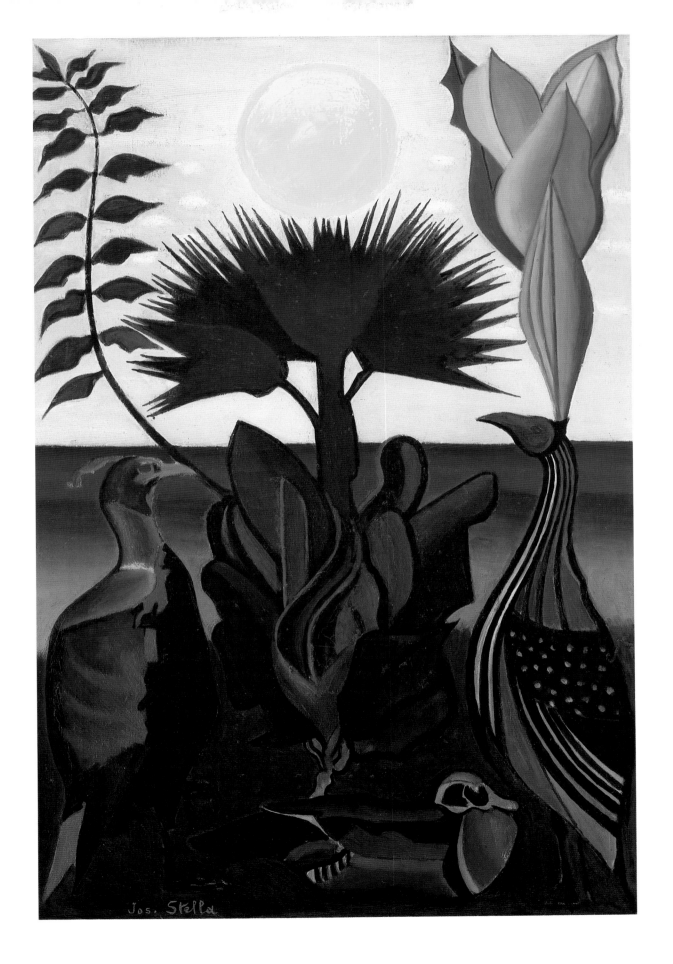

Jos. Stella

30
"SERENADE" A CHRISTMAS FANTASY (LA FONTAINE), n.d.
Oil on canvas, 43⅛ x 47⅛ inches
Hirshhorn Museum and Sculpture Garden
Smithsonian Institution
Gift of Joseph H. Hirshhorn, 1966
Photograph: Lee Stalsworth

Celestial peace descends from the heavenly sphere . . . and golden music
flows with rhythmic tenderness . . . the soul gathers itself in inward prayer.
The book of our life is opened like a gold reliquary, the center of our
life, and our whole being is illuminated like the host on an alter.

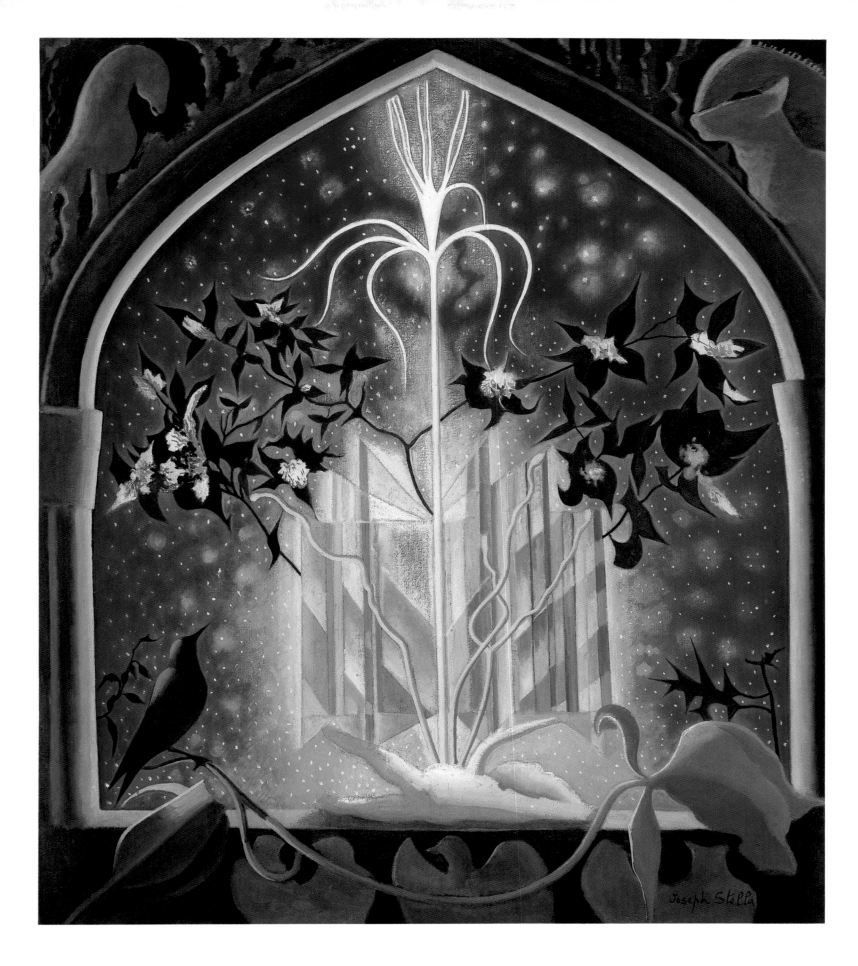

31
THE CRÈCHE, c. 1929-33
Oil on canvas, 61 x 77 inches
Collection of The Newark Museum
Purchase 1940
Wallace M. Scudder Bequest Fund

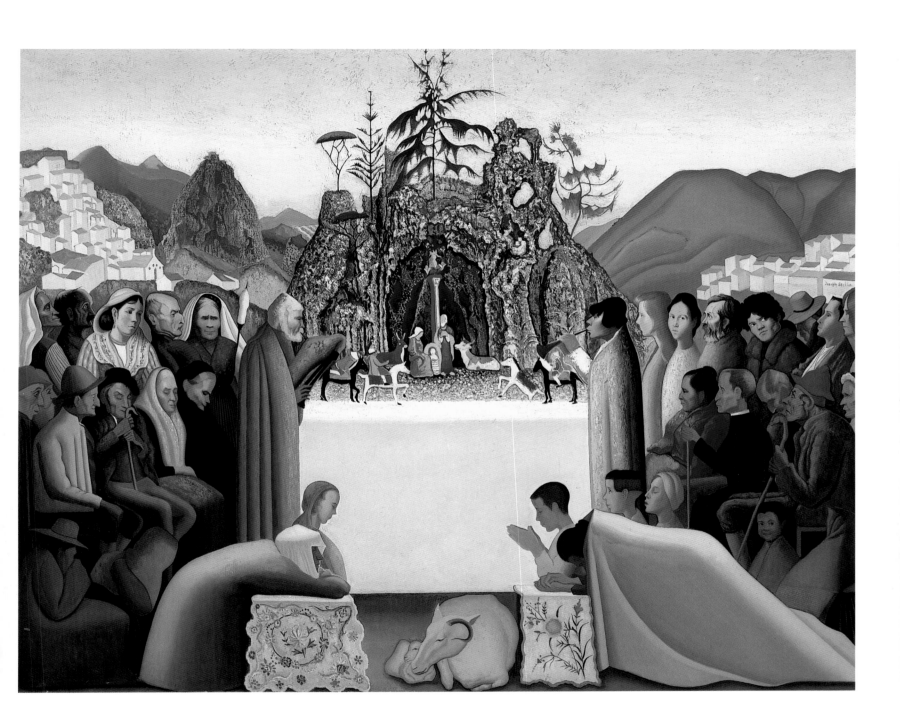

32
STILL LIFE WITH PUTTO AND FIGURINES, c. 1943
Oil and pencil, 20½ x 16½ inches
The Collection of Philip J. and Suzanne Schiller
American Social Commentary Art, 1930-1970

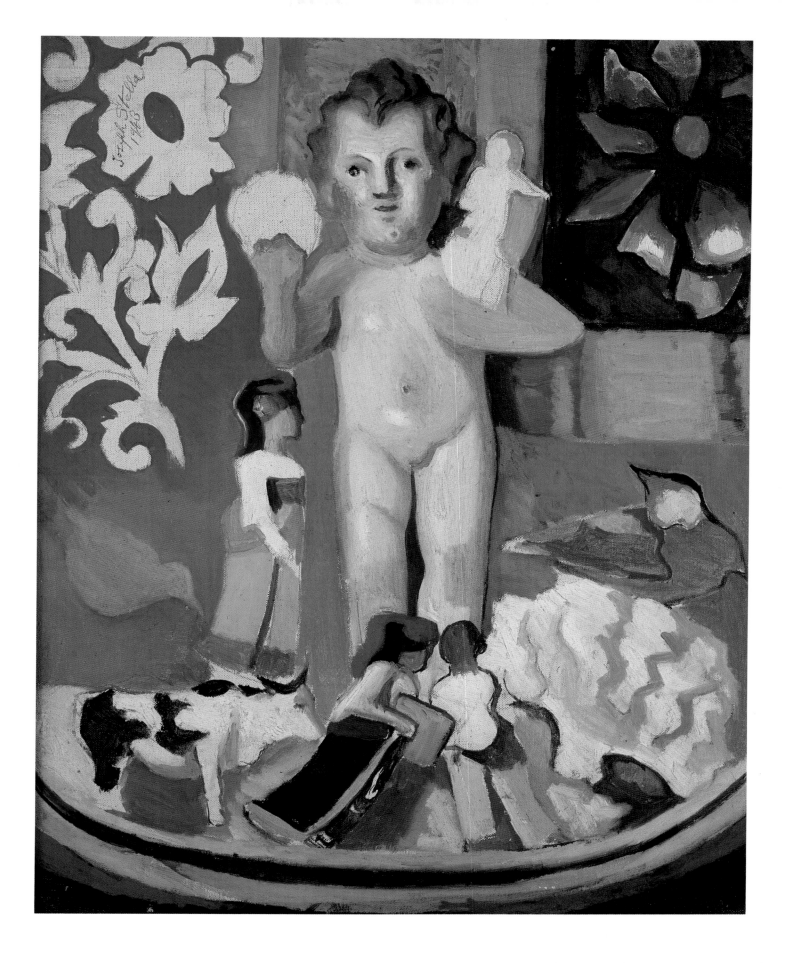

33
GOLDEN FALL, 1940
Oil on canvas, 26 x 20 inches
Courtesy of the Spanierman Gallery, New York City

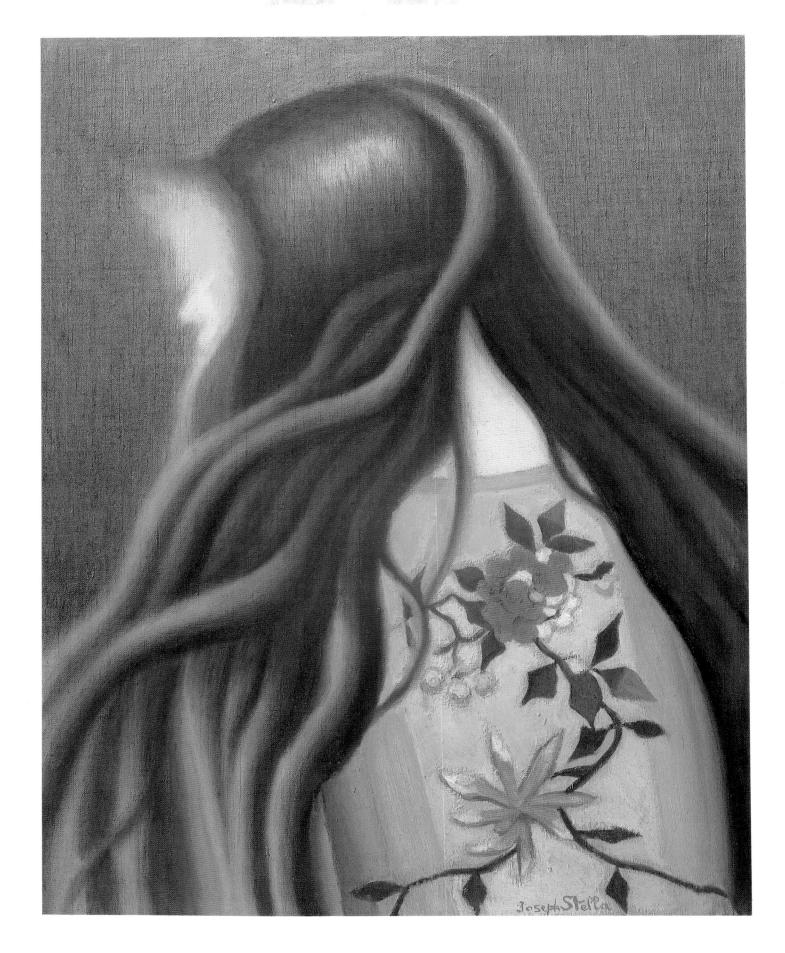

34
A FLOWER WITH FALLEN PETALS (STUDY FOR FLAMINGO), c. 1938
Crayon on paper
12⅞ x 9⅝ inches
Collection of Irma B. Jaffe
Photograph: Toby Old

Only one whose soul is pure, and profoundly good, can speak of the
superb beauty of flowers.

SELECTED BIBLIOGRAPHY

Baur, John I. H. *Joseph Stella*. New York: Praeger Publishers, 1971. Contains extensive bibliography.

Cassidy, Donna M. "The Painted Music of America in the Works of Arthur G. Dove, John Marin, and Joseph Stella." Ph.D. dissertation, Boston University, 1987.

Jaffe, Irma B. *Joseph Stella*. Cambridge, Mass.: Harvard University Press, 1970. Reprint, Fordham University Press, 1988. Contains extensive bibliography.

———. *Joseph Stella: The Tropics*. New York: Richard York Gallery, 1988.

———. "Joseph Stella in Barbados." *Latin American Art*, Spring 1991, pp. 30–32.

———. *Joseph Stella's Madonnas and Related Works*. New York: Snyder Fine Art, 1993.

Kramer, Hilton. "The Other Stella." *Art and Antiques,* January 1989.

Moser, Joann. *Visual Poetry: The Drawings of Joseph Stella*. Washington and London: National Museum of American Art, Smithsonian Institution, 1990.

Zilczer, Judith. *Joseph Stella: The Hirshhorn Museum and Sculpture Garden Collection*. Washington, D.C.: Smithsonian Institution Press, 1983.